SUSSEX AT WAR
THROUGH TIME
Henry Buckton

AMBERLEY PUBLISHING

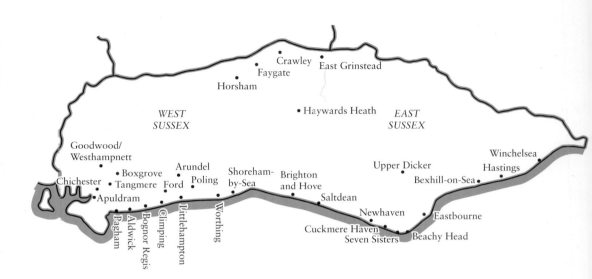

First published 2014

Amberley Publishing
The Hill, Stroud
Gloucestershire, GL5 4EP

www.amberley-books.com

Copyright © Henry Buckton, 2014

The right of Henry Buckton to be identified as the
Author of this work has been asserted in accordance
with the Copyrights, Designs and Patents Act 1988.

ISBN 978 1 4456 3839 3 (print)
ISBN 978 1 4456 3844 7 (ebook)

British Library Cataloguing in Publication Data.
A catalogue record for this book is available from
the British Library.

Typeset in 9.5pt on 12pt Celeste.
Typesetting by Fakenham Prepress Solutions.
Printed in the UK.

Introduction

In 1940, after the Germans had occupied the seaboard of northern France, every beach in Sussex became a potential invasion hotspot. From then until the end of the war, the county was in the thick of it and in this book we shall explore some of the ways it was affected. Today, of course, Sussex is divided into two separate counties, East and West, but our journey will include both and will largely stick to the coast, because it was here that most activity took place.

Among other things you will see how Chichester was the nerve centre for the county's civil defence organisation; how Tangmere and various other airfields stood fast during the Battle of Britain and later provided a springboard for the Allied aerial onslaught on German-occupied territories; how places like Bognor Regis, Brighton and Hastings were repeatedly bombed by the Luftwaffe, while Eastbourne was the most targeted place in the south-east outside of London. You will read how Worthing became a gigantic Army camp, the part that Newhaven played in the ill-fated commando raid on Dieppe, and how the county as a whole participated in the build-up of men and equipment before D-Day. Because of its close vicinity to the enemy's front line, Sussex remained at the forefront of wartime activity and hopefully this book will provide a good précis of the county and its people during those six years of hostilities.

Henry Buckton

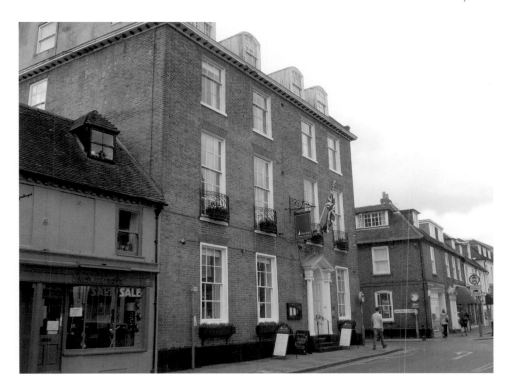

This shows the Ship hotel in Chichester where the Supreme Allied Commander General Dwight D. Eisenhower lodged before D-Day.

Acknowledgements

Photo Credits

Author: top 25, 26, 37, 41, 46, 73, 86, 90; bottom 3, 5, 6, 7, 8, 10, 11, 12, 13, 15, 16, 17, 18, 19, 20, 21, 22, 23, 24, 25, 26, 30, 31, 32, 33, 34, 35, 36, 37, 38, 39, 40, 41, 43, 45, 46, 47, 48, 49, 50, 51, 52, 54, 55, 56, 57, 61, 62, 63, 64, 65, 66, 67, 68, 70, 71, 72, 73, 74, 75, 76, 77, 78, 79, 80, 82, 83, 84, 85, 86, 87, 88, 89, 90.

Author's collection: top 13, 23, 30, 36, 43, 44, 45, 47, 48, 58, 59, 64, 68, 69, 70, 71, 72, 76, 81, 83, 84, 85, 88, 89, 91, 92, 94, 95, 96; bottom 91, 96.

British Automobile Racing Club: top 27, 29. Bundesarchiv: top 77, 78. Gravelroots: top 5. RuthAS: top 74. Michael Virtue, Virtue Books: top 7, 17, 18, 19, 20, 21, 22, 24, 28, 31, 38, 39, 42, 49, 50, 51, 57, 61, 63, 65, 66, 67, 75, 79, 80, 82, 87; bottom 42. West Sussex County Council Library Service: top 32, 33, 34, 35, 40, 52, 53, 54, 56, 58, 59, 62, 93; bottom 53, 94. 303rd BGA: top 6.

Thanks also to Ken Green and Hilary Sloan of the Chichester Local History Society for allowing the reproduction of images in the booklets *Second World War Bombing of Chichester* and *The Day the Liberator Crashed on Chichester*: top 8, 9, 10, 11, 12, 14, 15, 16; bottom 14.

I would also like to thank the following members of the Geograph website for the use of their photographs, licensed for reuse under the Creative Commons License.

Carl Ayling: top 60. Simon Carey: bottom 9. Nigel Chadwick: bottom 93. Paul Farmer: bottom 92. Graham Hale: bottom 60. Hassocks5489; bottom 69. Stuart Logan: bottom 27, 81. Christine Matthews: bottom 28, 29. Peter Trimming: bottom 44. Helmut Zozmann: bottom 95.

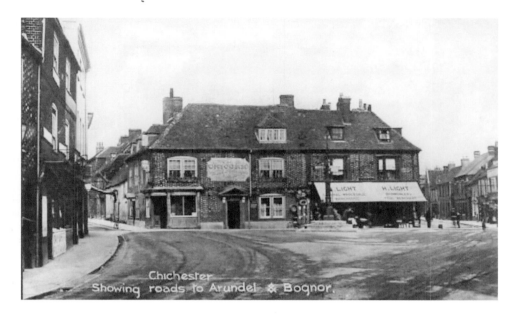

Chichester
Showing roads to Arundel & Bognor.

A City at War

Being close to several wartime airfields, the city of Chichester became a very popular destination for off-duty service personnel who would frequent places such as the New Plaza Cinema on South Street, now a supermarket, or the Unicorn pub in Eastgate Square, pictured above. Apparently, this was the favourite watering hole among pilots stationed nearby. Today, a newer building on the same site acts as the offices of the *Chichester Observer*, pictured below. Another draw for service personnel were the many dances held in the Assembly Room at the Council House, or at Kimball's Restaurant, now the site of Marks & Spencer in North Street.

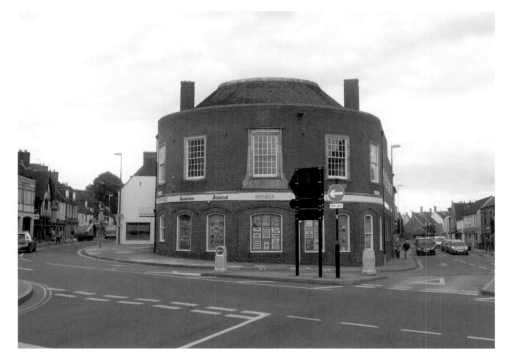

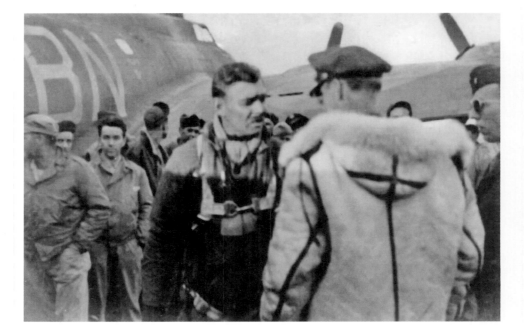

A Touch of Glamour

In 1943 a stir was caused when the Hollywood heartthrob Clark Gable attended a number of these dances. Gable was serving as a major in the United States Army Air Force (above) and, following a mission over the Continent, his B-17 Flying Fortress had to make an emergency landing on 30 June at the advanced landing ground at Apuldram near Chichester Harbour. While waiting for his aircraft to be repaired, Gable and his crew spent several enjoyable evenings in the city. Although nothing remains of the wartime airfield at Apuldram today, the board below looks out across the site, giving information about what took place here.

Arrival of the Evacuees

At the start of the war, Chichester, along with several other places in Sussex, was chosen as a reception area for a proportion of the 3 million mothers and children who were to be evacuated from London to the supposed safety of the countryside. From Friday 1 September 1939 the evacuees began to enter the county through eleven rail-heads (right) including Chichester station, pictured below as it looks today. From these they were taken in coaches and buses to billeting centres to be allocated their new homes. Chichester received a staggering 13,000 individuals, Worthing around 12,000, and other large towns taking similar numbers.

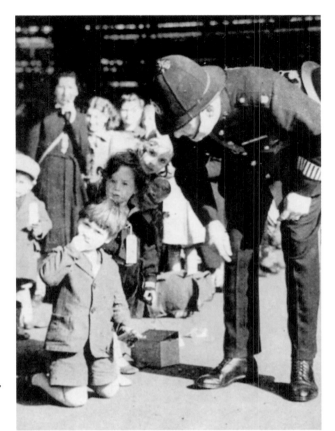

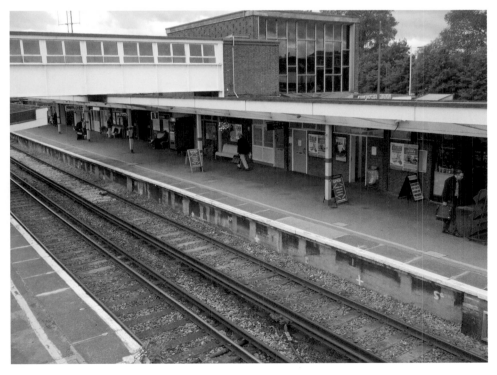

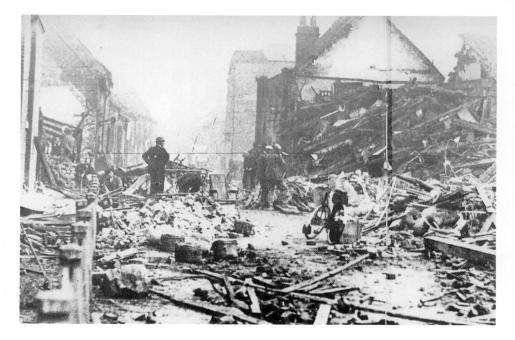

The First Significant Attack

In terms of bombing, the city of Chichester got off remarkably lightly compared to many other places in the county, especially those along the coast. In fact, it only suffered from three substantial raids. In the first of these, which took place in the early hours of Thursday 10 March 1941, two high explosive bombs were dropped on Basin Road and Southgate, causing damage to sixty-four properties, six of which were completely destroyed. One person was slightly injured. The photograph above shows some of the damage that was done to Chapel Street during the second of these raids. Below we can see Chapel Street as it appears today.

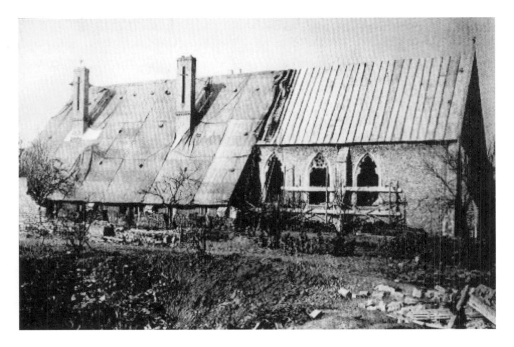

The Second Raid

As well as Chapel Street, in the second raid that occurred on the afternoon of Wednesday 10 February 1942, North Street, St Martins Street and Little London were also hit by a total of four bombs which killed eighteen people and injured around fifty others. Along with residential and business properties, several of the city's best-known buildings were also damaged. These included the thirteenth-century St Mary's Hospital, pictured above shortly after the attack, and below as it appears today. Also hit was the church of St Andrew's, which is now the Oxmarket Arts Centre. Even the cathedral itself lost a number of its stained-glass windows.

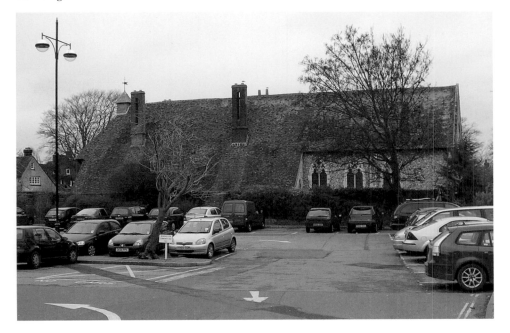

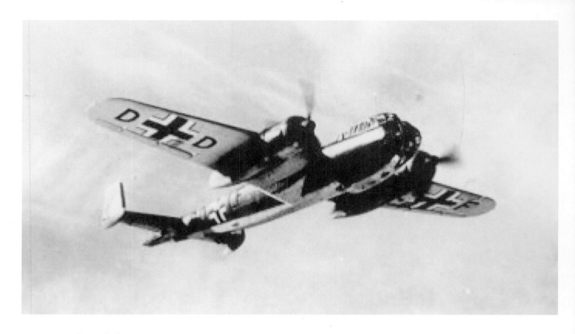

Demise of the Enemy

This raid is thought to have been carried out by a single Dornier 217-E4, similar to the example pictured above, which was subsequently shot down by anti-aircraft fire and crashed in fields near The Royal Oak public house at Lagness. It belonged to the Luftwaffe's Battle Wing No. 40, based at the Soesterberg Air Base near Utrecht in Holland, and had a crew of four, all of which died. Three of these, Oberfeldwebel Erich Dohring, Oberleutnant Hans Kleeman and Unteroffizier Gunther Ladwig, are buried in St Andrew's churchyard, Tangmere (below). The fourth, Obergefreiter Josef Eitenauer, was laid to rest in Chichester Cemetery.

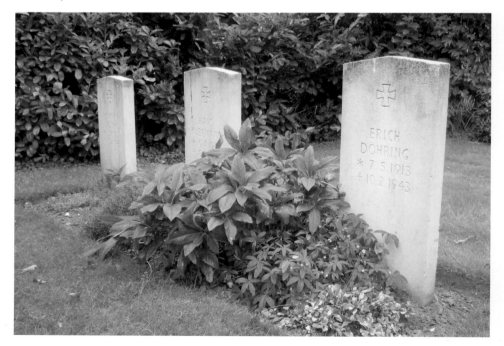

The Third Attack

The third and final attack of note took place just after midnight on 26 April 1944 and caused damage to Armadale Road and Bridge Road. In this raid a further seven people were killed, which brought the total of all those who died during air raids on the city of Chichester to twenty-five, with sixty-eight others sustaining serious injuries. In the photograph above, taken in Armadale Road, among the wreckage is an air-raid shelter. We can also see a civil defence rescue vehicle and residents trying to salvage some of their possessions. Below is the same spot today, which considering the devastation still looks remarkably similar.

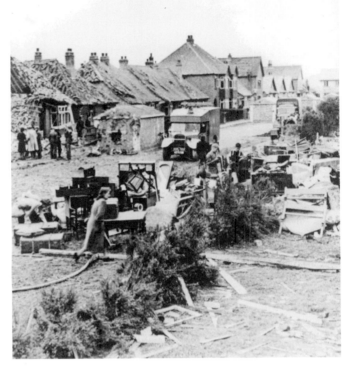

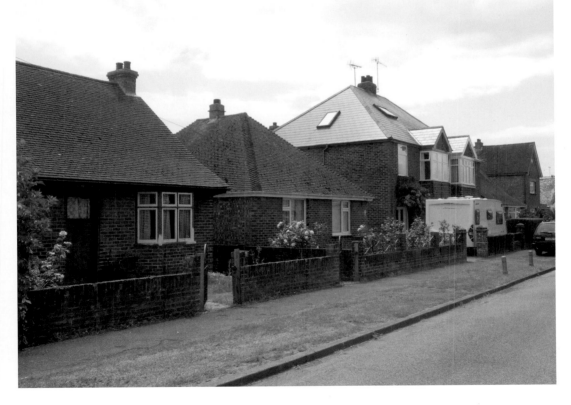

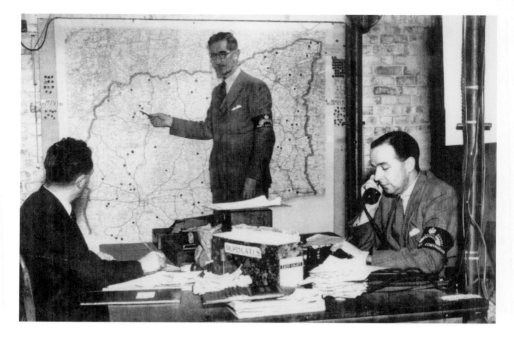

Civil Defence at Work

The responsibility of helping to protect people from such attacks fell on the civil defence organisation. Each local authority had a controller to direct this civilian army of air-raid precautions wardens, ambulance drivers, first-aiders, decontamination squads, and control staff. The nerve centre for West Sussex operated from the basement of County Hall in Chichester, seen below today, and was under the control of Tom Hayward, seen at the right of the picture above, who at the time was clerk of the county council. Also in the picture are William Huston the Assistant Controller (*left*), and Harry Sadler the County ARP Officer (*centre*).

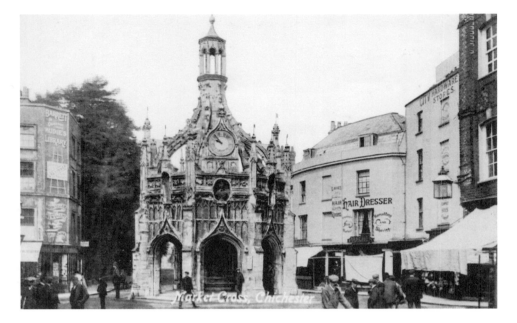

Praising the Volunteers

On 7 December 1939, many of the city's voluntary war workers assembled in County Hall to hear Queen Elizabeth praise their efforts thus far. The largest of these branches was the ARP, which had its own HQ at Greyfriars in North Street. It consisted of both male and female volunteers whose main occupation was to patrol the streets at night ensuring that there were no visible lights that might attract the attention of the German bombers. Above and below are contemporary and modern views of the Market Cross, which would have been a prominent feature for service personnel visiting the city, just as it remains today with tourists.

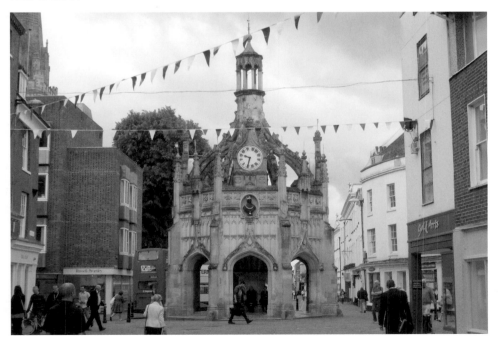

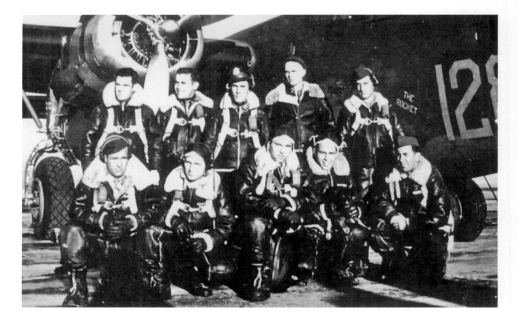

The Day the Liberator Crashed

Tragedy hit the city again on 11 May 1944 when an American Consolidated B24 Liberator (below), based near Ipswich, crashed on allotments that had been dug for the war effort on the site of the old Roman amphitheatre off Velyn Avenue, after being badly damaged by flak while on operations over France. The pilot of the aircraft, Lt Joseph A. Duncan, pictured in the centre of the back row above, and the rest of the crew, managed to bail out. But on crashing, the subsequent explosion scattered parts of the aircraft over a wide area and caused damage to over 700 properties, including a laundry where fifty women and girls were working.

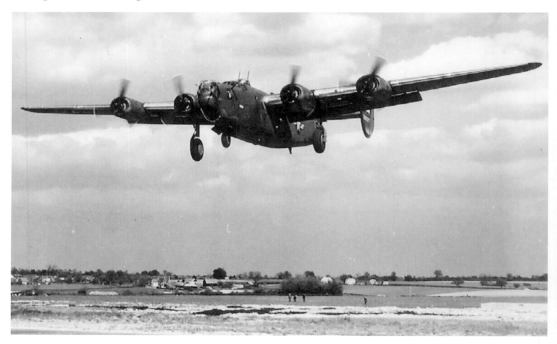

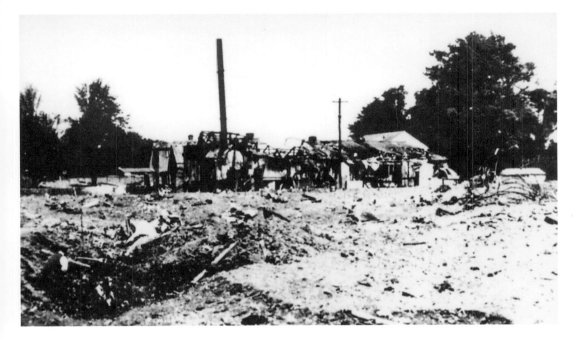

Damage Caused

Three people were killed by the crash: a fourteen-year-old girl, May Grainger; a fifty-eight-year-old lady, Mrs Elizabeth Tees; and a gentleman named Leonard Price who was working in the allotments. Fourteen others were detained in hospital. The photograph above of the crash site was taken the day after, while below we see the same spot today. After parachuting out of their stricken aircraft, the crew of the Liberator came down at various spots around the Selsey peninsula. Lt Duncan himself, who suffered from a broken leg, came to earth at North Bersted and was taken to a field hospital at Eastergate where his injuries were treated.

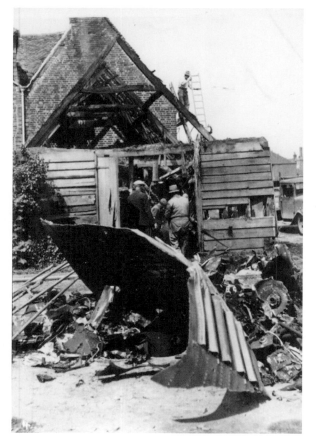

Hosting the Supreme Allied Commander

The photograph to the left shows further damage caused by the crashed Liberator, in this instance to a blacksmith's forge on the junction of Velyn Avenue and the Hornet, pictured below as it appears today. Chichester also played a part in plans for the invasion of Normandy as the first meetings to coordinate the D-Day plans were held at the Ship hotel in North Street. Here the Supreme Allied Commander General Dwight D. Eisenhower lodged from 19 to 21 April 1944, while he met with other members of the Supreme Headquarters Allied Expeditionary Force (SHAEF) and visited the RAF operations room at Bishop Otter College.

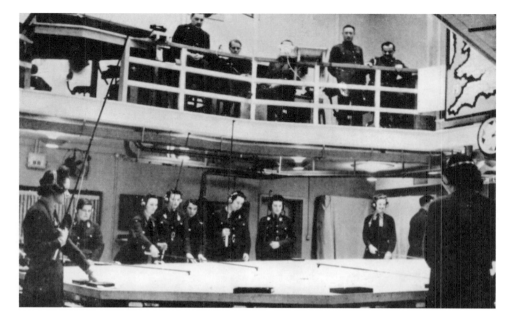

RAF Tangmere

East of Chichester is Tangmere, where an aerodrome first opened in 1917. In the late 1930s it was enlarged, with the RAF commandeering most of the properties in the centre of the nearby village and demolishing several more to make way for the construction of new runways. By the outbreak of war its strategic position had already been recognised and it was designated a sector station within No. 11 Group Fighter Command, which meant that it was equipped with an operations room like the one seen above. The memorial below can now be found in the grounds of the excellent aviation museum that occupies some of the site.

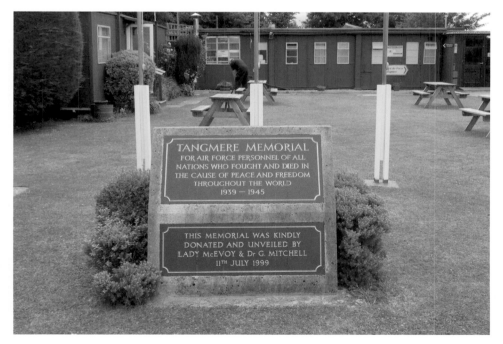

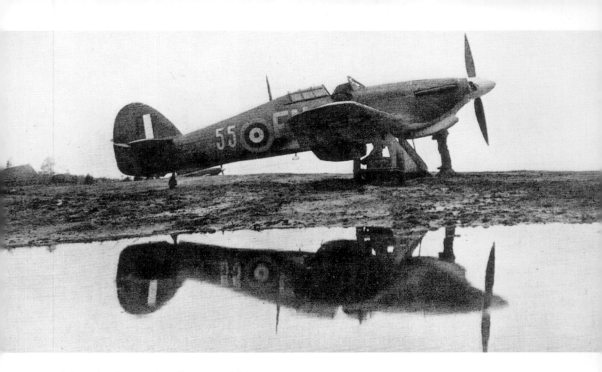

Helping the Evacuation from Dunkirk

When hostilities began a number of squadrons at the airfield had been equipped with the latest Hawker Hurricane fighters (above), some of which went to France as part of the British Expeditionary Force. However, when the situation on the continent took a turn for the worse in May 1940, those that had remained at the base would find themselves flying daily sorties over the beaches of Dunkirk to give air cover during the evacuation. The very last RAF unit to leave France, No. 73 Squadron, flew into Tangmere on 13 June 1940, before proceeding on to Church Fenton. The photograph below shows part of the airfield today.

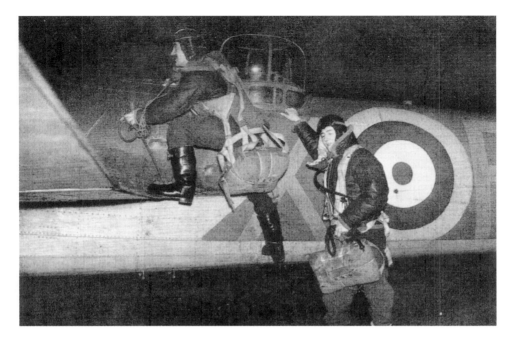

Fighter Interception

Tangmere found itself with only the English Channel between it and the German Army. When the Battle of Britain commenced in July 1940, the airfield had three Hurricane squadrons in residence. There was also the Fighter Interception Unit, equipped with Bristol Blenheims (above), whose task was to develop night-fighting techniques using an early form of airborne radar. From then until the climax of the battle at the end of October 1940, many other units came and went and the pilots stationed here would be in daily action against overwhelming numbers of enemy aircraft. The monument pictured below can be seen in the centre of the village.

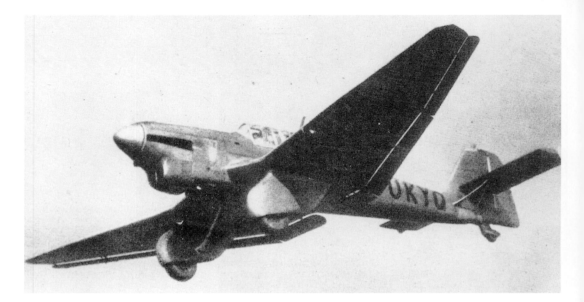

Tangmere Comes under Attack

At first the Germans attacked shipping in the Channel, but then turned their attention to airfields. On 15 and 16 August, Tangmere itself came under attack when hundreds of Stuka Ju 87 dive bombers, like the one above, assaulted the aerodrome, causing extensive damage to buildings and runways and killing numerous RAF and civilian personnel. Despite the damage, the vital equipment that helped the sector controller to direct the movements of his own aircraft was kept in service but was relocated to a school in Chichester. Below is part of an air-raid shelter at the museum which comes from one that was used here throughout the war.

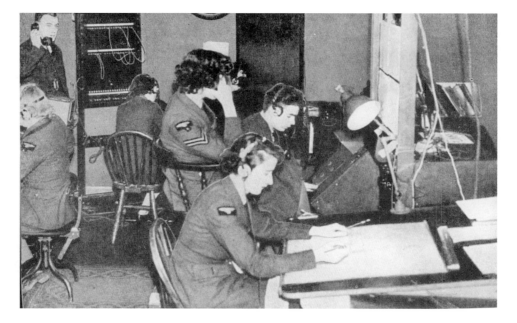

Winning the Battle of Britain

At a point at which the RAF was at its lowest ebb, the Germans changed their tactics again and began the intensive bombing of London. Although this was disastrous for the people of the capital, it was a godsend for airfields like Tangmere which could now rebuild and re-equip with new aircraft and pilots. This situation was undoubtedly one of the main factors that led to Fighter Command's ultimate victory and Hitler's decision to postpone and later cancel the invasion. Above, WAAFs are seen at work in the ops room and below is another memorial in Tangmere churchyard dedicated to all airmen whose grave was the sea.

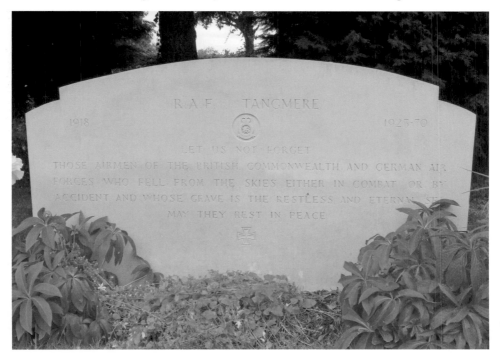

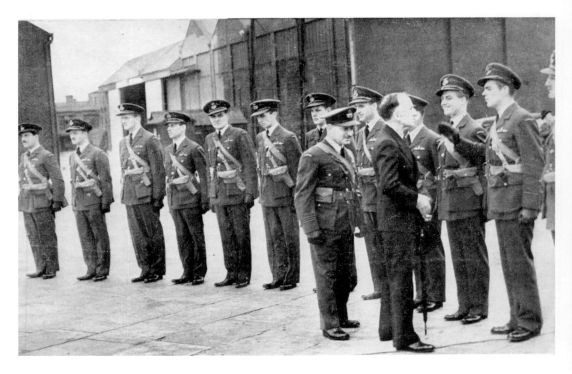

Formation of the Tangmere Wing

By 1941 the Battle of Britain was over. Now it was the turn of the RAF to attack the Germans in their occupied territories, and the newly formed Tangmere Wing began to fly sorties back across the Channel on the offensive. Among the many missions flown from Tangmere during the remainder of the war was Operation *Jubilee* on 19 August 1942, when a force of mainly Canadian troops landed on the coast of France at Dieppe; and D-Day on 6 June 1944, when Canadian Spitfire pilots from the base (above) took part in sorties over the beaches. Below is the scene across the airfield today looking towards the old control tower.

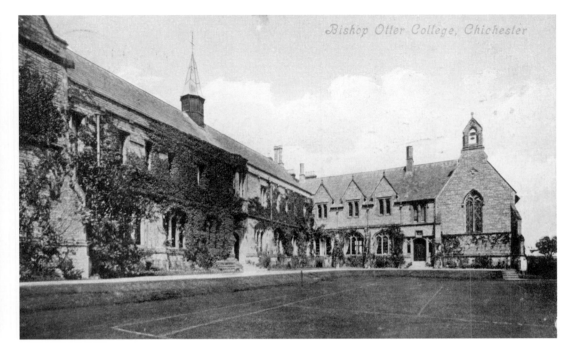

Bishop Otter College, Chichester

A New Operations Room

During the build-up to D-Day it was recognised that Tangmere needed a much larger operations room to deal with the increased air activity, so a new one was built inside Bishop Otter College in Chichester (above), which is now part of the university. It opened on 15 February 1944 and controlled fifty-six squadrons from eighteen different airfields, ranging from Lee-on-the-Solent in the west to Friston in the east. It was from here that the operational air support for D-Day was conducted. In the picture below, a model of a Spitfire towers over one of the buildings at the Tangmere Military Aviation Museum.

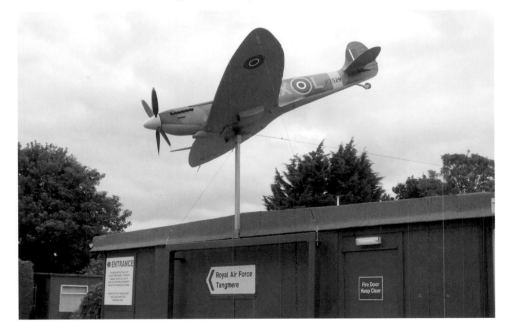

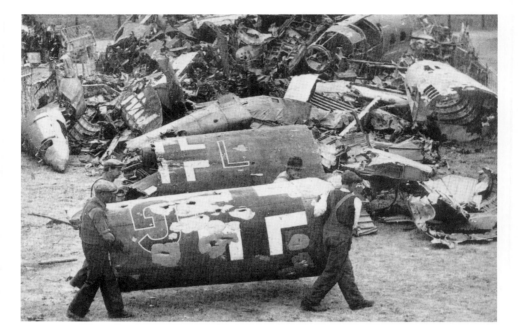

German Graveyards

Tangmere was in every sense a front-line battle station and many of those who were killed at the base are buried in the cemetery at St Andrew's church, which is tended by the Commonwealth War Graves Commission (below). Here, as we saw earlier, you will also find the graves of German airmen who died in battle over southern England. Another German graveyard of a different sort could be found at the village of Faygate between Horsham and Crawley, where the railway station was used as the Sussex No. 1 Salvage Centre (above). It was here that the remains of crashed enemy aircraft were taken by the military, with the help of civilian contractors.

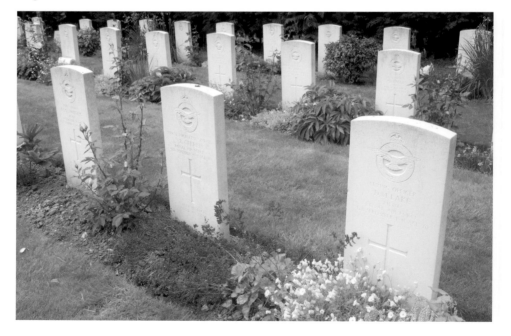

An Olympic Hero

In the churchyard of the priory church of St Mary and St Blaise at Boxgrove (below) you will find another interesting grave associated with Tangmere, that of Pilot Officer Billy Fiske (above), one of the first American citizens to die fighting with the RAF. Before the war Fiske had been a gold medalist with the US bobsled team at both the 1928 and 1932 Winter Olympics. At sixteen he was the youngest gold medalist in any winter discipline until his achievement was eclipsed in 1992. Already an American sports hero, he was given the honour of carrying the flag of the United States at the 1932 opening ceremony.

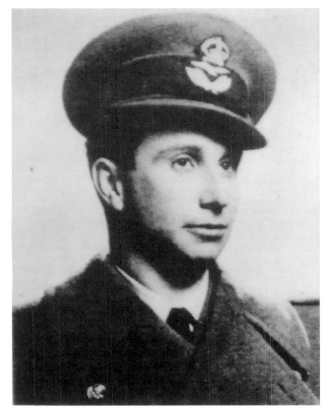

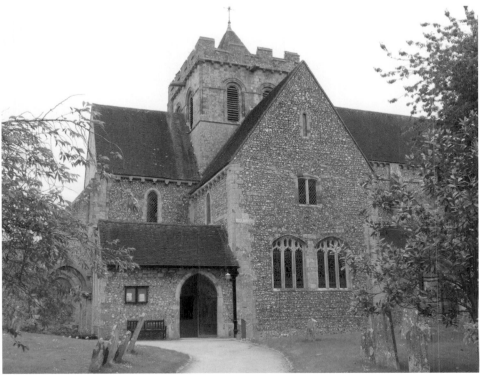

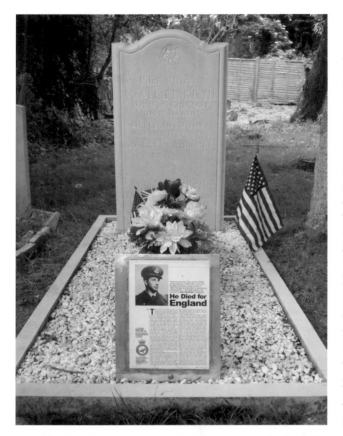

An American in the RAF

Shortly before the outbreak of war, Fiske came to England and was one of seven US citizens who fought in the Battle of Britain. After training he joined No. 601 Squadron at Tangmere in July 1940. On 16 August, one of the occasions when Tangmere was attacked, they were scrambled to intercept a group of Stukas. With his Hurricane badly damaged and himself seriously burnt, Fiske managed to nurse his aircraft back to the airfield. He was rushed to the Royal West Sussex Hospital in Chichester but died forty-eight hours later. Above is the grave, while below is a detail from a window dedicated to Fiske inside the priory church.

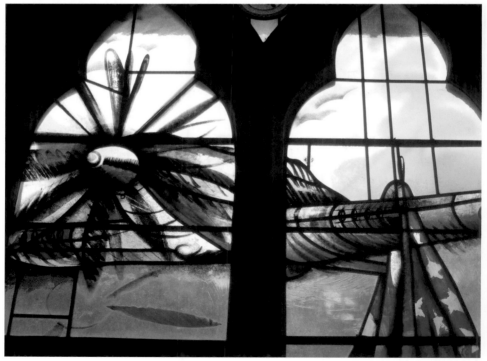

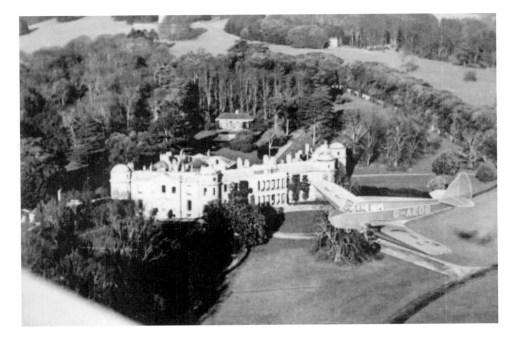

Satellite Airfields

Tangmere also had a number of satellite airfields, one of which, RAF Westhampnett, was created on land belonging to the Goodwood Estate. It had been donated to the war effort by the 9th Duke of Richmond, Freddie March, himself a renowned amateur motor racer and aircraft engineer. It was from here that the charismatic Douglas Bader flew his last wartime mission on 9 August 1941 with No. 616 Squadron while leading the Tangmere Wing. During the flight, in which he was at the controls of a Spitfire, he collided with a Messerschmitt Bf 109 and bailed out over northern France. Above and below we have earlier and modern views of Goodwood House.

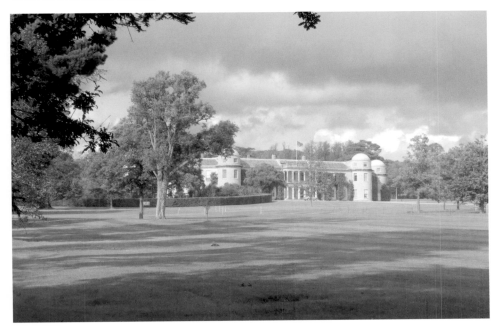

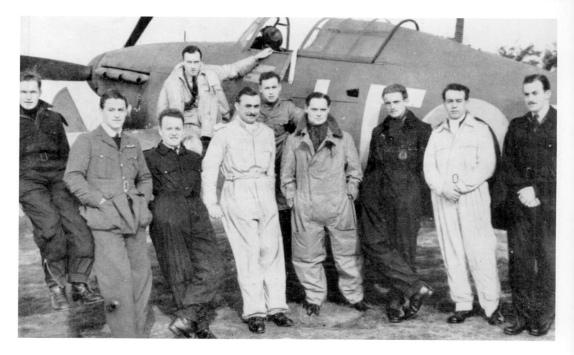

A Legendary Leader

Douglas Bader, pictured fourth from right above, was of course an inspirational leader who had lost both of his legs in a flying accident before the war; but despite this disability, he displayed flying skills and leadership qualities of the highest order, which have made him a household name to this day. One of No. 616 Squadron's most unusual wartime missions was to drop an artificial limb behind enemy lines to replace one which Bader had lost when his aircraft came down. In the photograph below a Spitfire is seen visiting the Goodwood motor racing circuit in 2010, with a Hawker Hurricane in the background.

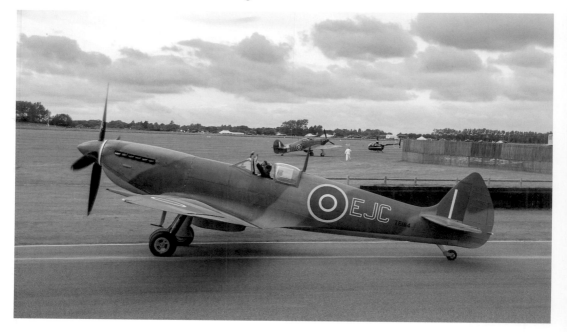

Motor Racing at Goodwood

It was also from here that in August 1942 the 31st Fighter Wing of the 8th United States Army Air Force, equipped with Spitfire Vbs, flew the first American-involved combat missions in the European theatre, after their arrival in England. By D-Day the airfield was back in RAF hands, and from here No. 184 Squadron in Typhoons flew some of the very first sorties of the day. After the war, the perimeter track of the airfield was converted into a racing circuit, which was opened in September 1948 by Freddie March (right) himself to host Britain's very first post-war motor race at a permanent venue. Below, cars are seen racing on the modern circuit.

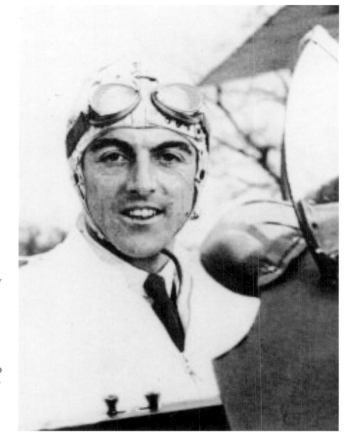

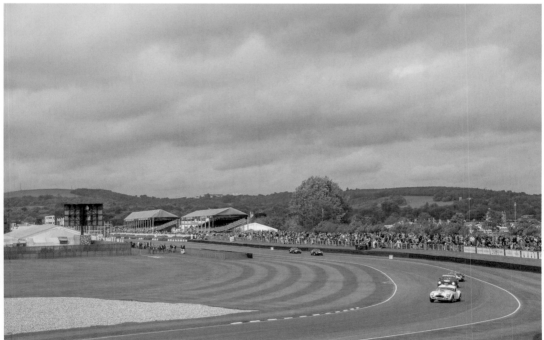

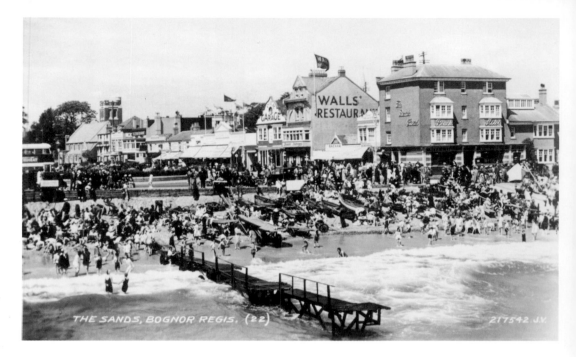

THE SANDS, BOGNOR REGIS. (22) 217542.J.V.

Bognor Regis Goes to War

To continue our exploration of wartime Sussex we will be largely travelling east, along or very near the coast, and our next stop is the popular seaside destination of Bognor Regis, where, during hostilities, the pier was taken over by the Royal Navy and used as an observation platform. It was renamed HMS *Patricia* and armed with anti-aircraft guns as part of the town's air-raid defences. The postcard above shows the seafront at Bognor Regis in the 1930s. This photograph would have been taken from the pier and below we see the same view today, remarkably devoid of bathers despite being taken on a summer's day.

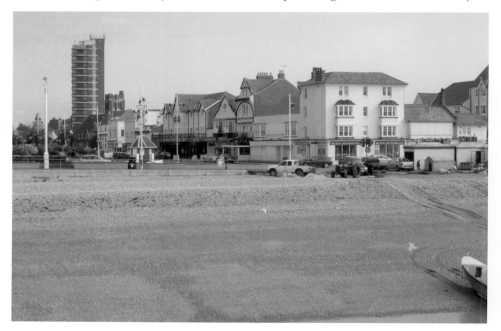

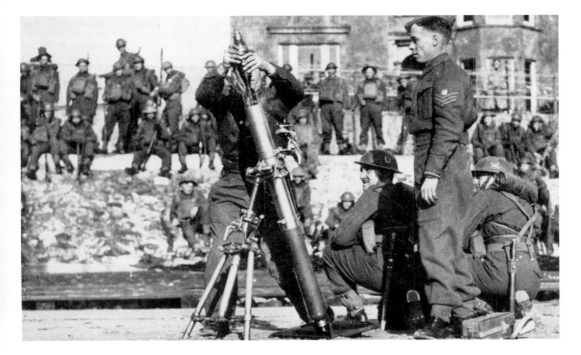

A Demonstration on the Beach

The Army also deployed in the town to be ready in the eventuality that the Germans attempted a seaborne landing in the area. In the photograph above, soldiers gather on the seafront to watch a demonstration in using a mortar. The photograph below shows the probable location of this scene today. Although the German Army didn't attempt the incursion in question, their air force certainly made an impact. In fact, being so close to the enemy's front line on the other side of the English Channel, it was almost inevitable that when the bombers began to cross the coast in 1940, the town would be subjected to numerous attacks.

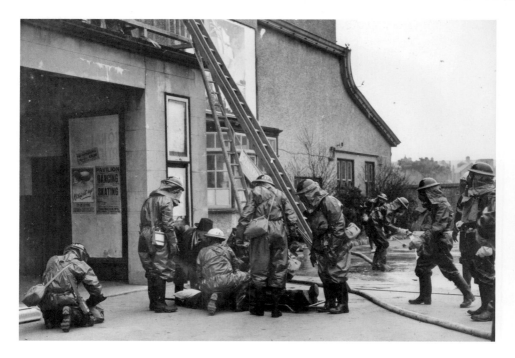

Exercising at the Old Pavilion

According to a report in the *Bognor Regis Observer* in October 1944, during the course of the war the civil defence organisation in the town, members of which are seen above exercising at the old Pavilion, issued no less than 1,291 air-raid warnings, although it is not clear how many of these were genuine alerts that resulted in bombing. Those that did would cause damage to about 3,000 properties, of which fifty-eight were completely destroyed. In total twenty-one people were killed with another 160 receiving recorded injuries, while 374 people had to be rehoused. The photograph below is a study of Bognor Regis pier today.

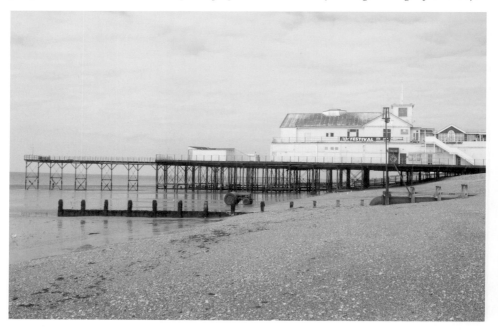

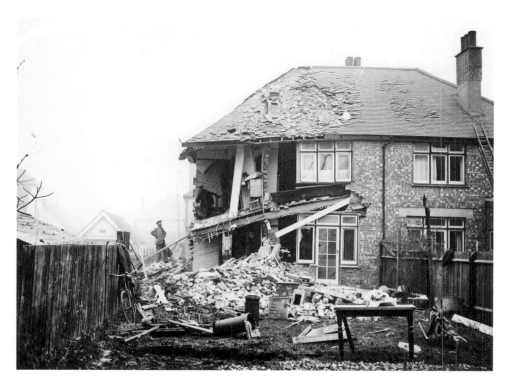

Bombs over Bognor

The first bombing of any real severity was on 27 September 1940 when fifteen bombs were dropped over Highland Avenue and Sherwood Road, which resulted in one death and damage to a number of houses. The final raid, which also killed only one person, took place on 27 August 1944 when a V1 flying bomb landed in the gardens between Shelley Road and Tennyson Road. The photograph above shows the damage caused to one of the houses in Highland Avenue, while below the avenue is seen today in rather more peaceful circumstances.

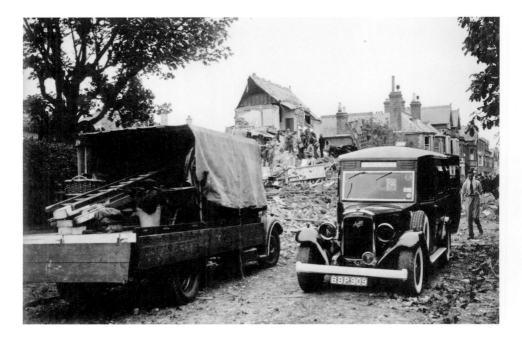

Worst Raid on the Seaside Town

The photograph above shows damage that was done to Sudley Road on 14 August 1942 during what turned out to be the worst air raid to hit Bognor Regis. On this occasion the enemy dropped four 250kg bombs which hit Burnham Avenue and Surgess Road, and a single 1,000kg bomb that did the damage to Sudley Road, seen below as it appears today. Look carefully at the above picture and you will see people looking through the debris; some of them would have been civilians and some officials either retrieving possessions or searching for survivors – a familiar scenario for those living in the bombed towns along the south coast.

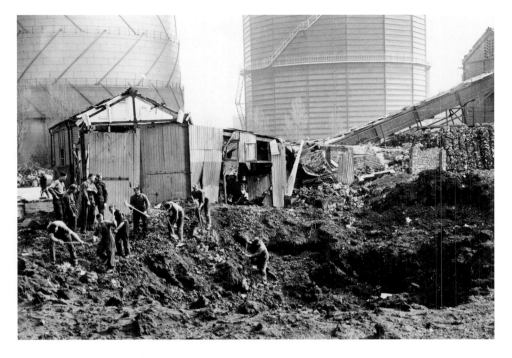

Attacks on the Gasworks

The most attacked area of Bognor Regis was around the gas works in Shripney Road, and in fact a German bomber actually crashed into one of the gasholders during one such raid. Above we see soldiers with pickaxes working in a crater caused by a bomb near the gasworks. Below we see Shelley Road today, another area of the town to be the subject of enemy action as previously mentioned. Although several areas of the town experienced bombing and were affected by the war in other ways, some of the most interesting wartime relics around Bognor can be found along its beaches.

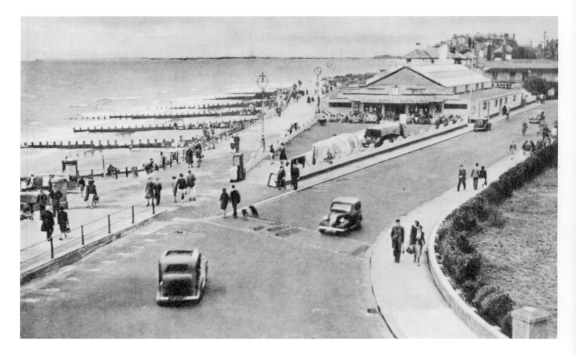

Western Sand Enclosure

Above is a postcard of Bognor's Western Sand Enclosure in the late 1930s or possibly the 1940s. During the war itself the beach was covered in barbed wire and other defences in fear of enemy troops making a landing here. Below is the same enclosure now, pictured from a different angle. On the seafront at Pagham, you will find a monument which was erected to mark the fifty-fifth anniversary of D-Day, as it was here that huge sections of the Mulberry Harbours started to arrive in early May 1944. By 5 June some fifty of these 6,000-ton caissons had been assembled between Pagham Beach and Selsey.

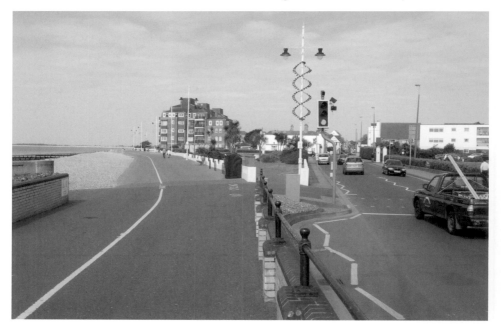

Sunken Giants

To hide them from enemy view, the caissons were sunk to await refloating when the invasion got under way. One section remains in the water off Pagham Beach, having proved impossible to re-raise. Above we see the monument in question. Mulberry Harbours were of course built by the Allies to enable supplies and men to be landed in Normandy following the invasion, without the need to capture enemy-held ports. Another of the caissons can be found on Aldwick Beach (below). Apparently, this section broke loose from its tow line in rough weather and ended up here on the shore, now providing a fascinating piece of flotsam.

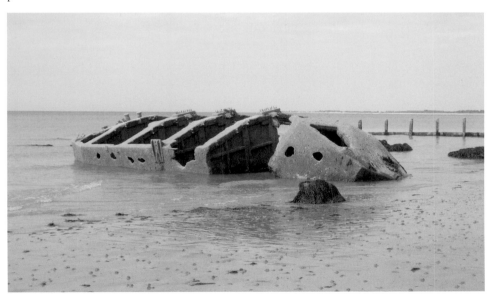

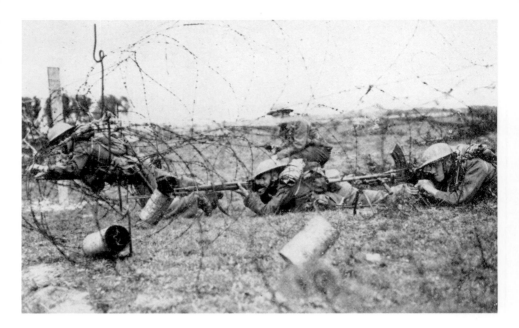

Exercise *Fabius*

Climping Beach (below) was one of several coastal stretches from here to Slapton Sands in Devon that was used during Exercise *Fabius*, the largest amphibious training exercise ever staged and the final dress rehearsal for D-Day (above). These huge manoeuvres took place between 3 and 8 May 1944, and were judged a success by the Allied commanders, which gave them the confidence to go ahead and commit to the actual invasion. At Climping elements of the 3rd British Infantry Division practised for their assault on Sword Beach, while at Bracklesham Bay the 3rd Canadian Infantry Division trained for their landings on Juno Beach.

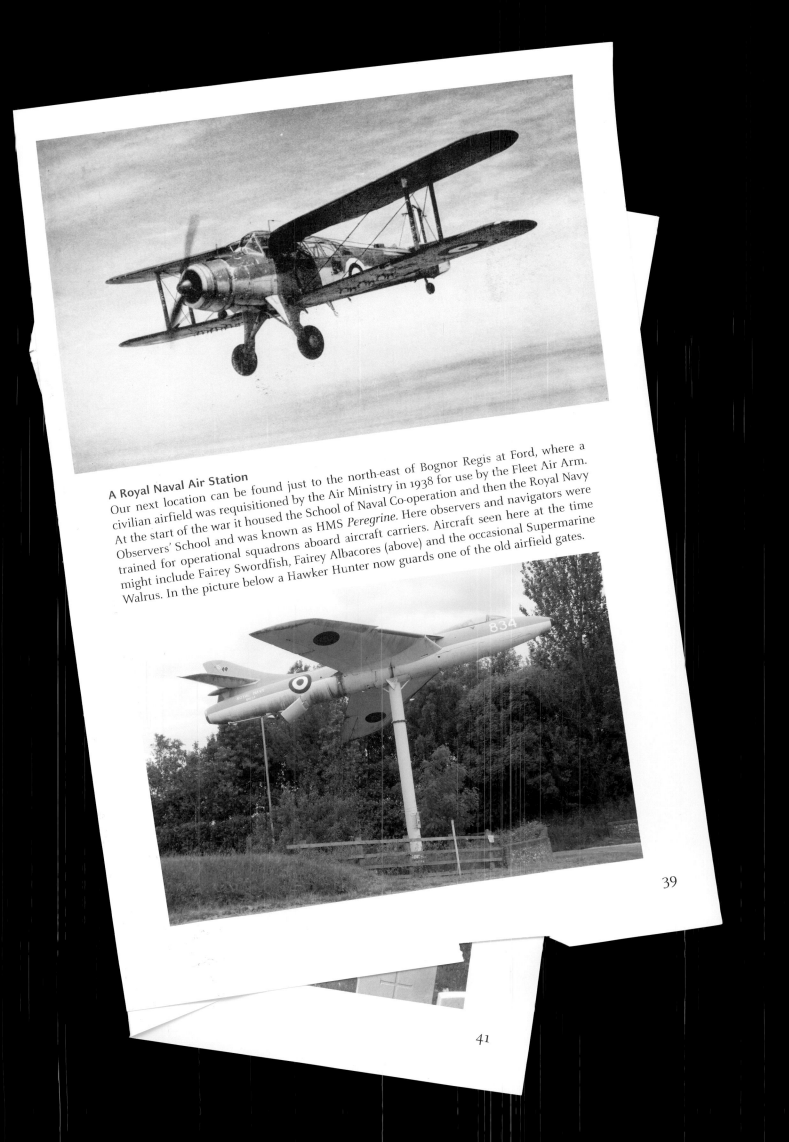

A Royal Naval Air Station

Our next location can be found just to the north-east of Bognor Regis at Ford, where a civilian airfield was requisitioned by the Air Ministry in 1938 for use by the Fleet Air Arm. At the start of the war it housed the School of Naval Co-operation and then the Royal Navy Observers' School and was known as HMS *Peregrine*. Here observers and navigators were trained for operational squadrons aboard aircraft carriers. Aircraft seen here at the time might include Fairey Swordfish, Fairey Albacores (above) and the occasional Supermarine Walrus. In the picture below a Hawker Hunter now guards one of the old airfield gates.

Changing Hands

The airfield was left crippled by the attack and it would be some time before it fully recove...
In the meantime, the Royal Navy relinquished the base to Fighter Command and it became...
Ford in September 1940. Its first occupants were No. 23 Squadron, flying Bristol Blenheims...
with a rudimentary radar system which enabled them to operate as night fighters (abo...
below). They were later joined by the Fighter Interception Unit, which had been at Ta...
until it was bombed with most of its aircraft destroyed on the ground. At Ford it conti...
develop the techniques employed by aircrew using airborne radar systems.

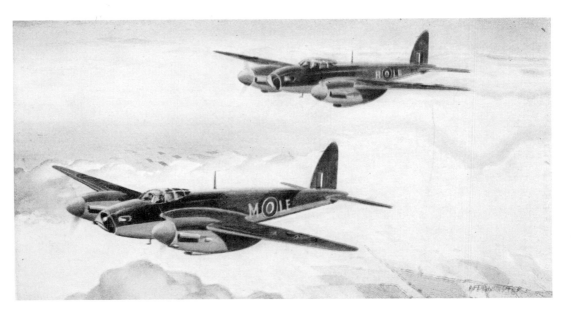

Night Fighting from Ford

Squadrons based at Ford took part in major operations including Operation *Jubilee* on 19 August 1942 and Operation *Overlord* on 6 June 1944. The station remained largely dedicated to night fighting and aircraft used here included Mosquitos (above). Ford was later allocated to the Allied Expeditionary Air Force and the night fighters were replaced by RAF units with Mustangs. On D-Day itself, Canadian squadrons flying Spitfire Mk IXs provided top cover for troops as they assaulted the beaches. The graves of many of those who died while serving here can be found in Littlehampton Cemetery (below), where there are also thirteen German war burials.

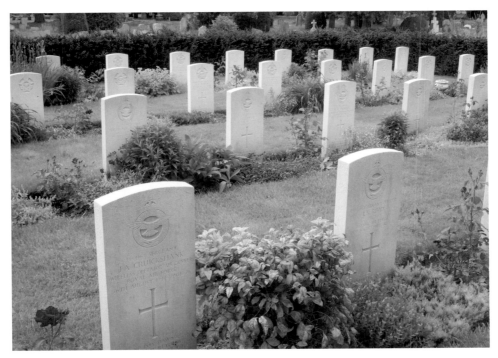

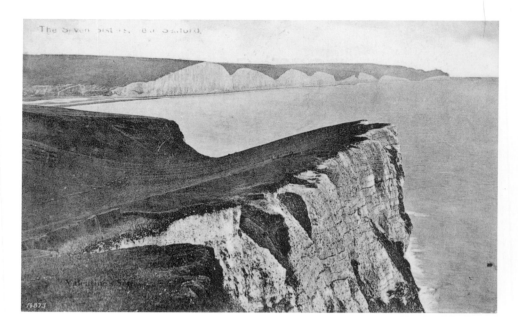

Anti-Diver Operations

In the final stages of the war some of the units at Ford equipped with Mosquitos flew what were known as anti-diver operations to intercept the V1 flying bombs as they crossed the south coast. Other Sussex airfields involved in anti-diver operations included RAF Deanland and RAF Friston, which was sited in what is now the Seven Sisters Country Park from 1940 to 1946. This was a grass airfield used as a base for fighter aircraft of No. 11 Group Fighter Command. Little evidence of the site now remains, but apparently during the summer of 1944 the aircraft based here accounted for several dozen flying bombs. Above and below are pre-war and modern views of the Seven Sisters.

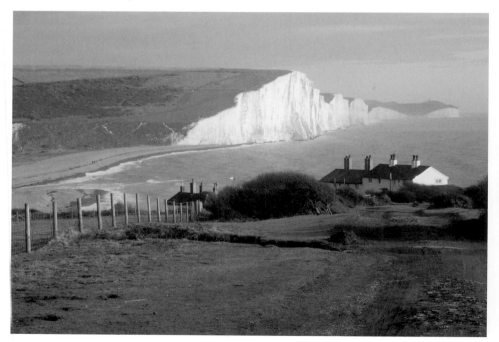

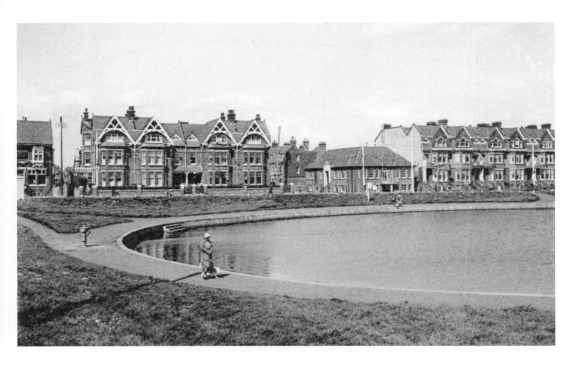

The Oyster Pond

Littlehampton was also bombed by the Germans on numerous occasions, with an estimated 3,000 bombs dropped on the town, 1,000 homes damaged, and ninety-two people killed or injured. One of its more unusual contributions to the war effort was in providing a base for a Royal Marine Commando group called 30 Assault Unit, who were accommodated in civilian billets around the town, mainly guest houses. Above and below we have contemporary and modern views of Littehampton's famous Oyster Pond, which was once used by local fishermen to store their catch of local lobsters and oysters, hence its name.

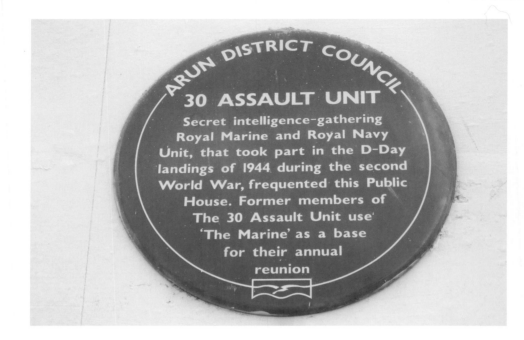

30 Assault Unit

The plaque above, which is on the wall of the former Marine Hotel on Selborne Road in Littlehampton (below), explains that 30 Assault Unit frequented the premises prior to D-Day. Here they are believed to have prepared for covert missions behind enemy lines ahead of the advancing Allied troops in France and later Germany, where they would seize military documents from enemy establishments. Their missions were largely picked and planned by the novelist-to-be Commander Ian Fleming, who was recruited into the Royal Navy in 1939 as the personal assistant of Rear Admiral John Godfrey, the director of naval intelligence.

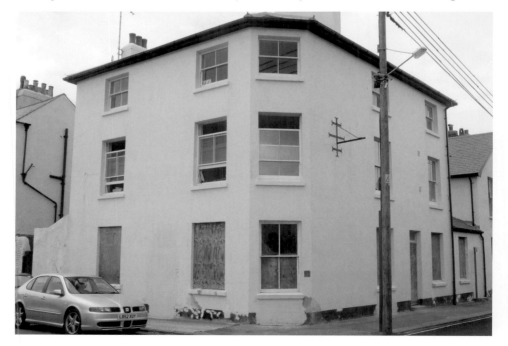

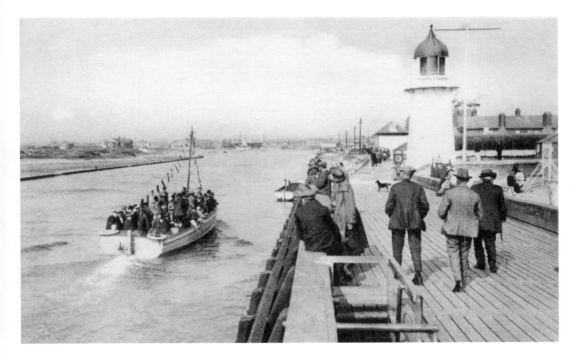

Red Indians

Fleming directed operations from his headquarters and for this reason he was unpopular with those under his command, who disliked his referring to them as his 'Red Indians'. But no doubt his admiration for those who undertook these stealth raids was inspirational in the creation of his most famous literary character, James Bond. During the invasion itself, the harbour at Littlehampton was used as an ammunition supply post, with ships from here carrying its lethal cargo to the Allied armies across the Channel. Above and below we have different views of the entrance to the harbour at Littlehampton along the River Arun.

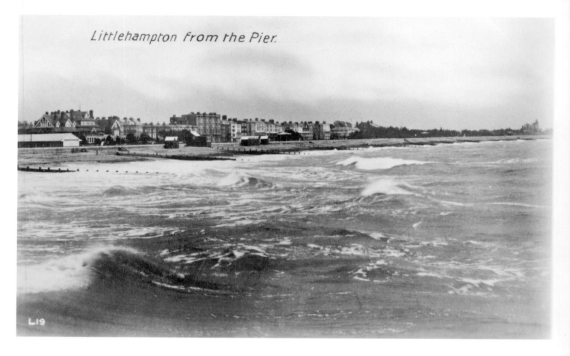

Littlehampton from the Pier.

Entertaining the Kids

Before the raid on Dieppe, the members of Canadian Black Watch, in their kilts, were billeted in Littlehampton, with Americans appearing prior to D-Day. Both groups were known to entertain the local children: the Canadians with displays of marching and military bands, and the Yanks with a Christmas party which included musicians and conjurers. The boatyards of Littlehampton were kept busy throughout the war building craft such as fast motor torpedo boats and launches for the RAF's air-sea rescue service. Above is an old postcard of the seafront, while below we have a modern study of the west bank of the Adur, where many boats were built.

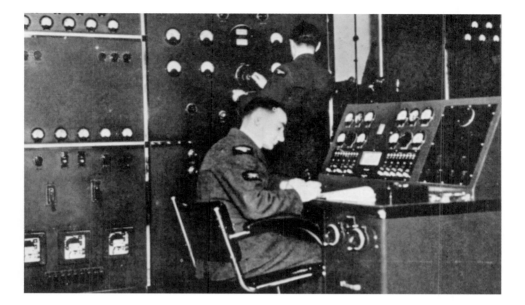

Radio Direction Finding

On the afternoon that Ford aerodrome was first attacked on 18 August 1940, so was the radar station at Poling, which stood in fields just to the north-east of Littlehampton on the site pictured below. During the Battle of Britain, radar, or radio direction finding as it was then known, was Fighter Command's secret weapon. At Poling there was a series of giant masts. They were part of Britain's early warning system, without which we may not have won the battle, or indeed the war itself, as they had the ability to detect enemy aircraft as they crossed the Channel. Above we see some of the sophisticated equipment that could be found inside a radar station.

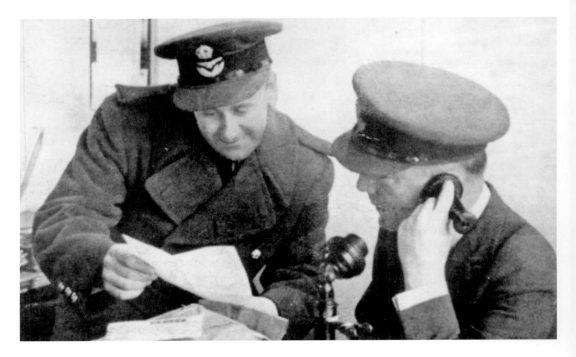

Armed Response

Radar allowed the controllers (above) at sector airfields like Tangmere to direct their own fighter aircraft on to the enemy. Although the Germans didn't know exactly what the masts along the Sussex coast were, they had at least determined that they were an integral part of Fighter Command and one of the reasons why Spitfires or Hurricanes always seemed to know exactly when and where their own aircraft would cross the coast. During the attack it is thought that some thirty-one Ju 87s dropped an estimated eighty-seven bombs. There is little evidence of the establishment today except the pillbox below which formed part of the site's defences.

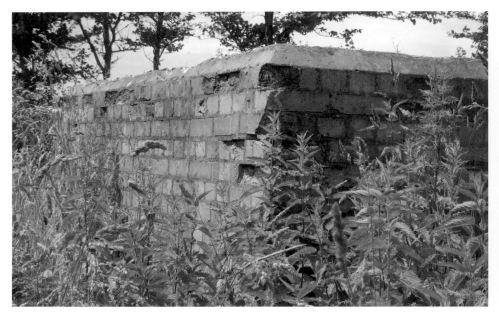

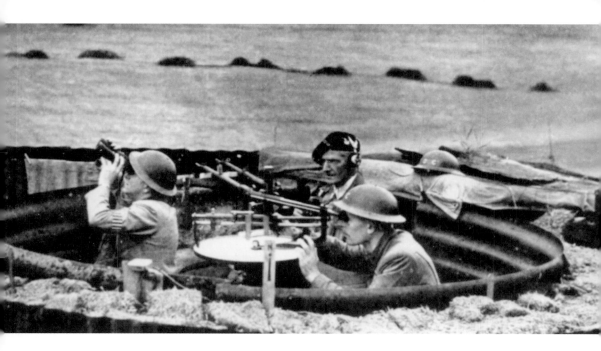

On the Lookout
But as well as the radar chain, there was the Observer Corps who visually plotted all aircraft that crossed the coast from hilltop locations throughout the county (above). All of this data was sent to the operations room of No. 2 Group in Denne Road, Horsham, and from there passed to Fighter Command. The information gathered by the Observer Corps and radar was a winning combination that always kept the Royal Air Force in the running, as it faced overwhelming odds and devastating aerial attacks. The structure below can now be seen at the site of where there had been a wartime Observer Corps post on Beachy Head.

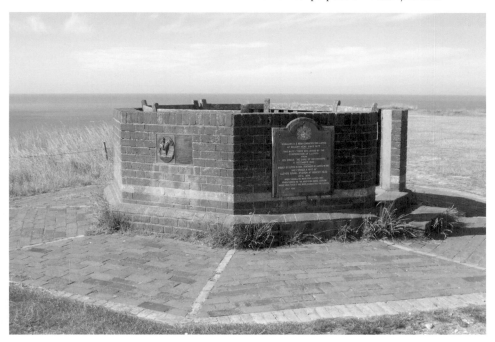

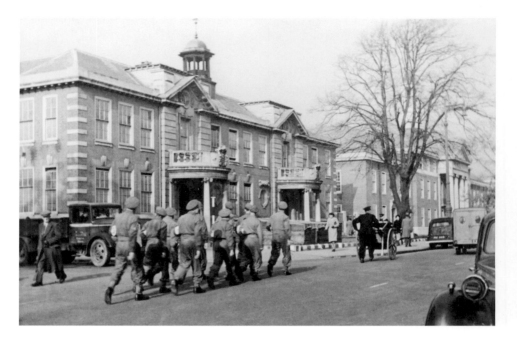

Turning Worthing into an Armed Camp

Continuing our journey along the coast, the town of Worthing was also attacked by the Germans on a great number of occasions. Throughout the war, because of its position directly opposite the German front line on the other side of the Channel, Worthing was virtually transformed into a huge Army camp. At first these soldiers were there to defend the coast from a seaborne invasion and later, after the threat had receded, to prepare for the second front. In the photograph above for instance we see troops marching past the town museum and art gallery in Chapel Road, which can be seen in the picture below as it is now.

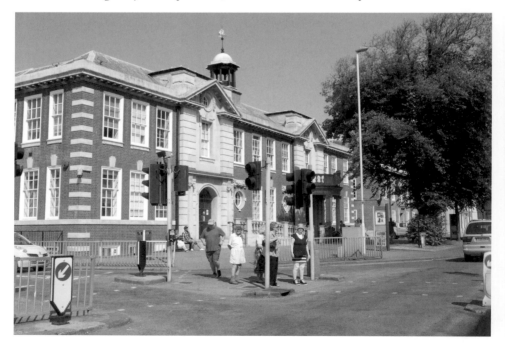

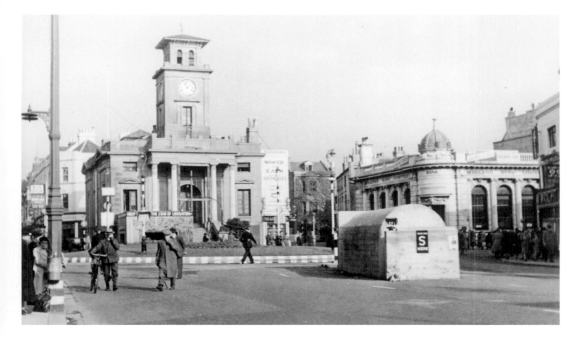

Air-Raid Shelters

Worthing, similar to all towns, soon had public air-raid shelters in prominent places built out of concrete. In the case of Worthing this was not only in order to protect the civilian population, but also the huge number of military personnel who suddenly found themselves living and working in and around the town. In these photographs we have two fine examples of shelters that could be found in public areas. The one above can be seen near the old town hall, looking north from South Street. Also noticeable are the kerb stones in front of the town hall painted black and white to help road users in the blackout. The picture below is of a shelter outside the Odeon cinema.

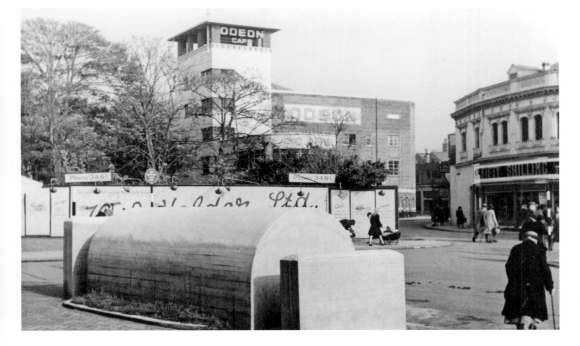

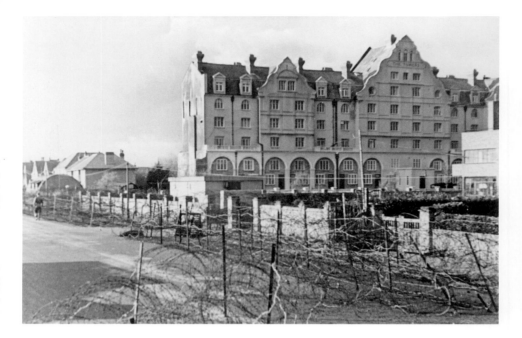

Protecting the Seafront

In June 1940, after the evacuation of the British forces from Dunkirk, General Bernard Montgomery was put in command of the 3rd British Infantry Division, to defend the Channel coast between Brighton and Bognor Regis against the invasion that most people feared would quickly follow. For this purpose he used Wiston House near Steyning as his headquarters. Montgomery took the task very seriously and ideally would have evacuated the entire civilian population from the coast. In the photograph above we can see the junction of Grand Avenue and West Parade during the war, with barbed-wire barricades, while below is the same scene today.

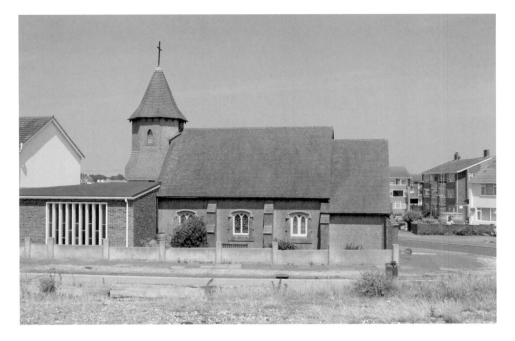

The Demolition of Bungalow Town

Montgomery ordered the demolition of any properties that he thought would hinder his troops as they tried to defend the beaches. Perhaps most notable was the destruction of Bungalow Town along the beach at Shoreham-by-Sea, which disappeared after the residents were given forty-eight hours to leave. Following the demolition, virtually all that remained was the Church of the Good Shepherd (above). The mural below on the seafront is now a reminder of the community that once lived there, largely comprising artists who had built their own rudimentary dwellings from former railway carriages acquired from the nearby carriage works at Lancing.

Blocks on Beach Parade

Whether or not these measures were totally necessary, the truth was that Hitler's invasion strategy did intend to take advantage of the flat coastline of Sussex for landing troops and tanks of the German 9th Army. Other anti-invasion measures put in place along the coast included barbed-wire barricades, while barrage balloons were just one of the measures adopted to protect against glider landings. Pillboxes armed with machine guns and a variety of anti-tank obstacles were also hurriedly built, such as the line of concrete blocks constructed along Beach Parade in Worthing that are seen in the picture above. Below is the same location today.

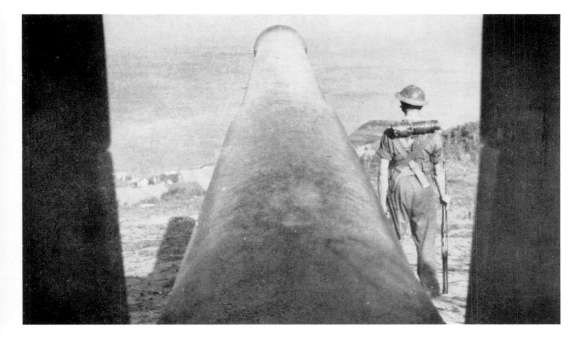

Coastal Guns

From the coast a network of pillboxes and other associated defences followed strategic lines of communications up the Arun and Adur valleys to form stop lines that would prevent the enemy from advancing inland. Major front-line defences comprised emergency batteries of ex-naval 6 inch guns, positioned roughly seven miles apart (above). The remains of one example can still be seen on Castle Hill, just to the west of Newhaven Fort (below). It was built to complement the firepower at the fort itself and originally fielded three guns. One of the positions has since been converted into the coastguard lookout station.

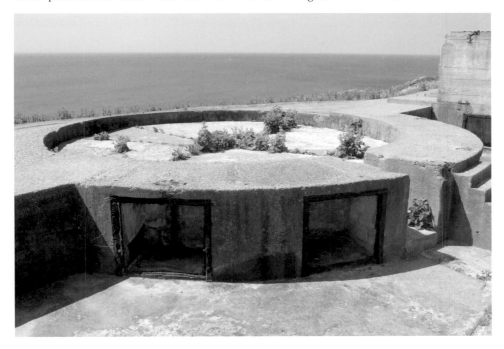

The Home Guard

Smaller anti-aircraft batteries also watched and waited, while searchlights were manned by the 70th (Sussex) Searchlight Regiment Royal Artillery. No. 461 Battery for instance used the Connaught Theatre in Worthing as its drill hall. There was also of course the Home Guard, twenty-six battalions of which were raised in Sussex. Above we see the men of Worthing photographed in front of Beach House, pictured as it is today below. Ready for the invader they patrolled both the coast and the South Downs and guarded strategic points such as road blocks, bridges and railway lines. They might have also guarded bomb sites, or crashed aircraft.

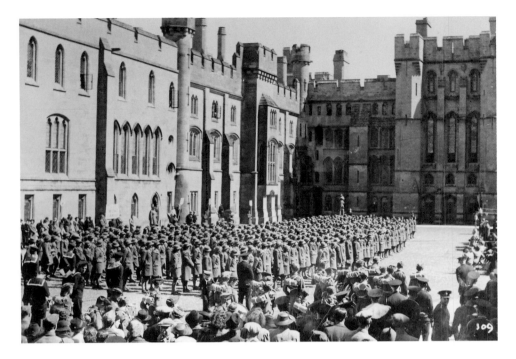

Women's Land Army

Organisations for women also played a vital role during the war. One of the best known, the Women's Land Army, had its national headquarters at Balcombe Place near Haywards Heath, the home of the honorary director Lady Denman. The photograph above shows a WLA rally at Arundel Castle taken in May 1943. The majority of Land Girls lived in the countryside but more than a third came from London and other industrial cities. The members worked in agriculture to replace men who had been called up to serve in the armed forces. Volunteers were later supplemented by conscripts. Below is a study of Arundel Castle today.

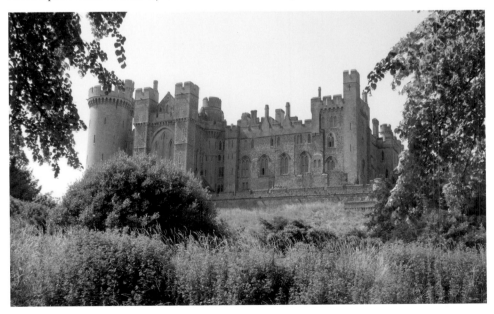

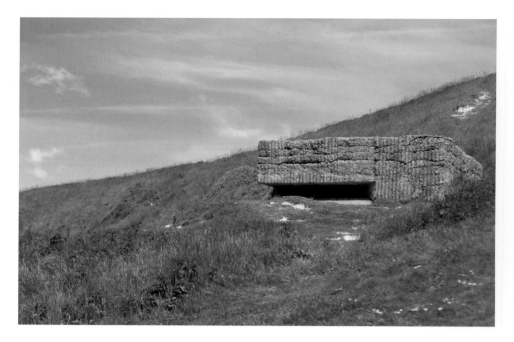

Unknown Soldiers

One of the best places to see these defences is at Cuckmere Haven, where pillboxes like the one above, as well as anti-tank obstacles, ditches and tank traps all survive. Cuckmere Haven featured heavily in the war effort when lights were placed to confuse bombers into thinking they were over Newhaven. The memorial pictured below stands on the west side of the Cuckmere valley and was erected in 2006 to commemorate the deaths of unknown Canadian soldiers camped in the field and killed in an air raid in 1940. It was erected on the basis of the testimony of a local war veteran who laid poppies here every Remembrance Sunday until his death in 2004.

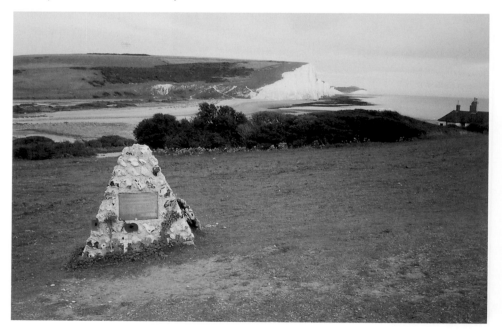

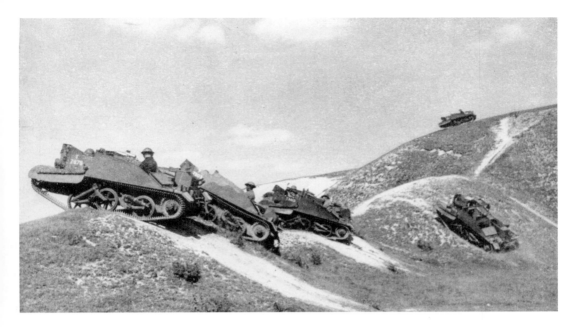

The South-Eastern Army

On 2 July 1940, Winston Churchill visited General Montgomery to observe an exercise of troops held at Lancing College led by the Royal Ulster Rifles. In December 1941, Montgomery was put in charge of the whole of South-Eastern Command and controlled not only the defence of Sussex, but Kent and Surrey as well. He renamed his command the South-Eastern Army to promote offensive spirit and organised large training exercises which culminated with Exercise *Tiger* in May 1942, involving 100,000 troops. The photograph above shows Bren gun teams training somewhere on the Sussex Downs, while below we see a pillbox near Shoreham.

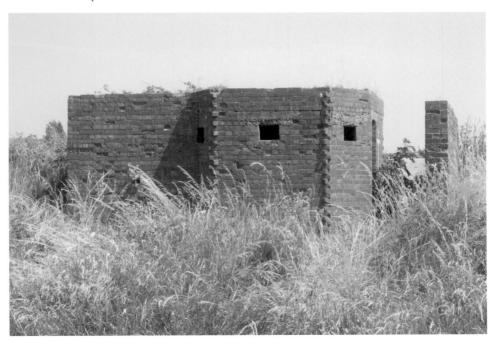

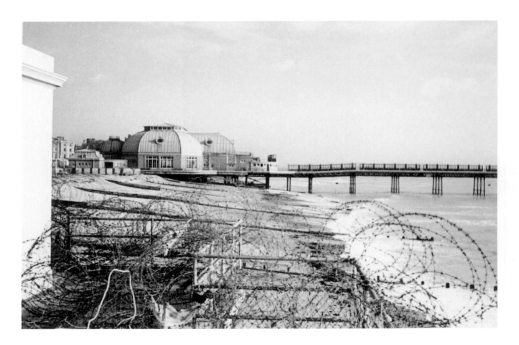

The Canadians Take Control

When Montgomery was eventually promoted away in 1942 to gain immortality in the North African deserts, the more relaxed 2nd Canadian Infantry Division took over the defence of the area, much to the relief of the local residents, although it has to be said that by that time the threat of invasion was slight. Also, some of the measures imposed by Montgomery at least gave the locals a taste of what would happen prior to D-Day, when once again their homes would be requisitioned and their movements completely curtailed. Above we see the pier at Worthing during hostilities and below as it now appears without the barricades.

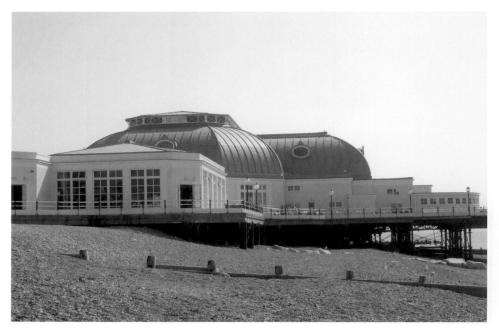

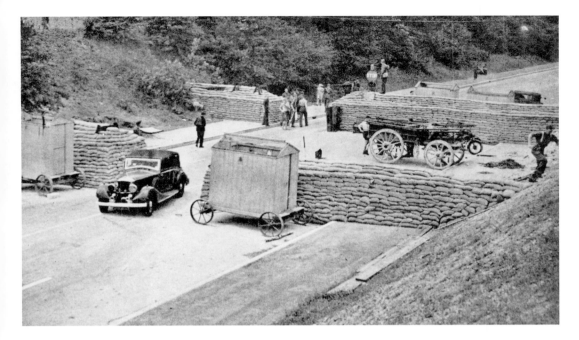

No Entry

At this time Worthing was destined to become the home and training base for numerous Allied units, including the 4th Armoured Brigade, who arrived in February and used the Eardley House Hotel on Marine Parade as their headquarters. By now this whole stretch of coast had been cordoned off with road blocks stopping any unauthorized persons from entering (above). So for the people of Worthing, who once again had servicemen living in their homes, it must have been something of an upheaval. Although this particular establishment was later demolished, it has now been rebuilt as luxury flats, in a style sympathetic to the original (below).

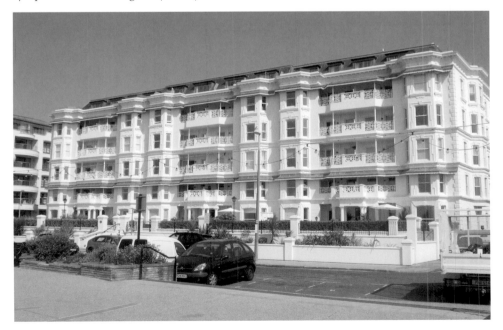

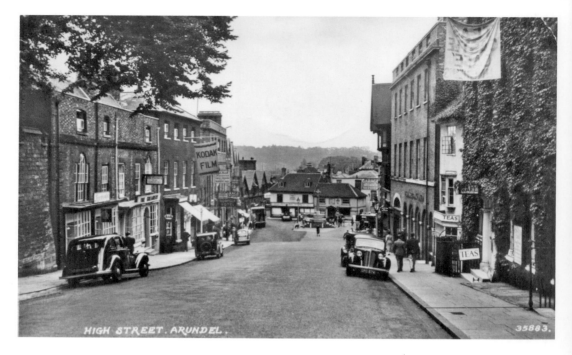

HIGH STREET. ARUNDEL. 35883.

Training Around Arundel

Also in Worthing, a number of British Commando units moved into properties on the Broadwater Road. The 15th Scottish Division made the now demolished Beach Hotel its HQ and dispersed its artillery between Worthing, Lancing and Ashington. In Goring-by-Sea, a large mansion called Courtlands was taken over as the headquarters of the Canadian 1st Army. And by the end of February, the United States 30th Infantry Division was undergoing intensive training in the Arundel area, where vast tracts of countryside had been requisitioned for this purpose. Above is the High Street in Arundel in the 1940s with the same scene reproduced below today.

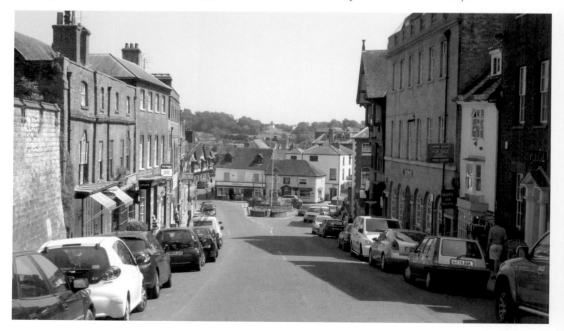

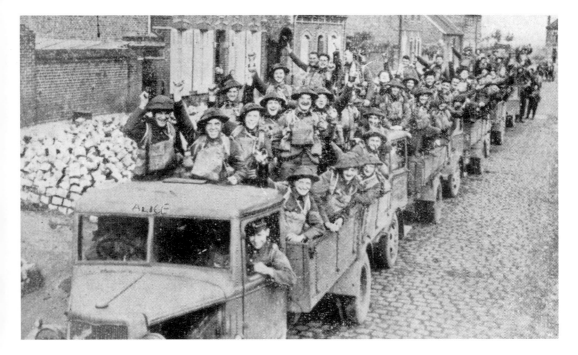

Gathering for D-Day

Both General Eisenhower and Winston Churchill visited the area to watch these manoeuvres. Then, as D-Day drew ever closer, even more troops began to pile into Worthing (above) in order to be near their embarkation points, notably Portsmouth, Southampton, and, more locally, Shoreham Harbour, seen below today. For instance, Alinora Crescent was lined with Bren gun carriers; Wallace Avenue with Churchill tanks; and Latimer Road with light tanks. Then on Saturday 26 May all military camps were sealed with an absolute ban on movement. By 28 May the roads of Sussex thronged with columns of vehicles moving to the ports.

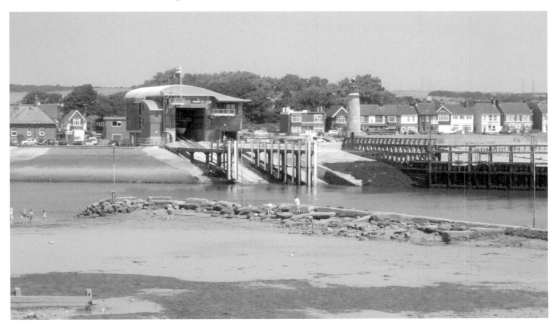

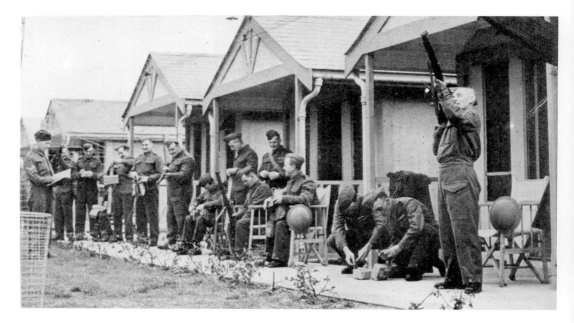

Tricking the Enemy

In Worthing, where people had become accustomed to the sight and sound of troops, suddenly these had vanished overnight, leaving the town in peace and quiet. Just before D-Day, General Montgomery, who was by that time the senior British *Overlord* commander, made an appearance before troops on Broadwater Green. However, it wasn't actually Monty but his double, an actor called Clifton James, who, due to his resemblance to the general, was used to trick the enemy over the possible date of the invasion: a ruse which apparently worked very well. Above we see men of the Pioneer Corps using beach chalets and below Courtlands which was the Canadian HQ, today.

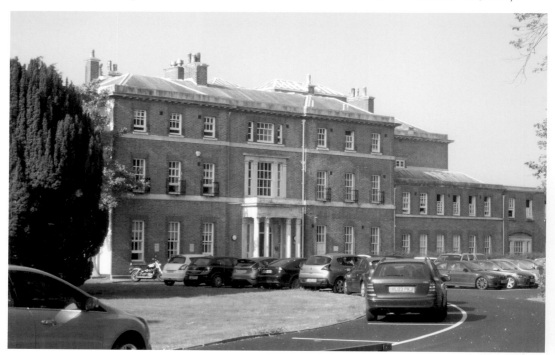

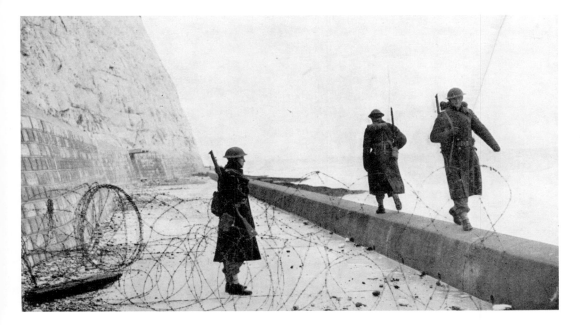

Defending the Undercliffs

In the 1930s, Brighton, as it is today, was one of the most popular seaside resorts in the country. In 2000, to mark the millennium, in combination with Hove, Portslade and a number of other surrounding communities, it was granted city status by Her Majesty Queen Elizabeth II. Sixty years earlier, at the height of Hitler's invasion threat, it suffered a similar fate to its neighbour Worthing. At 5 p.m. on 2 July all of its beaches were closed to the public. They were then mined and bordered with barbed wire. Here for instance we see soldiers guarding the undercliffs somewhere between Brighton and Saltdean, which is now also incorporated in the new city (below).

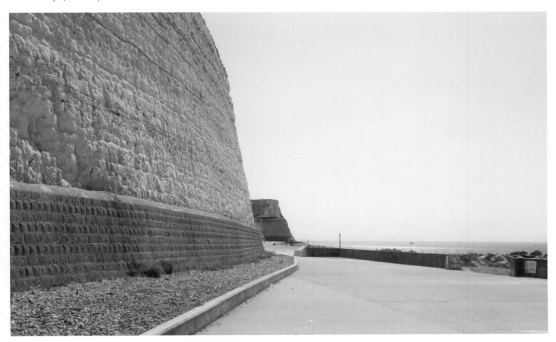

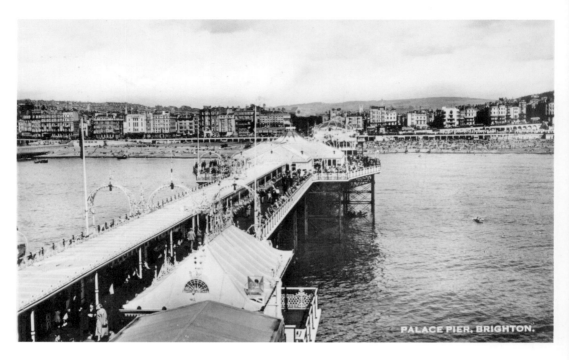

PALACE PIER. BRIGHTON.

Preventing the Enemy Landing

In Brighton, both the Palace Pier (above) and the now derelict West Pier had sections of their decking removed to prevent enemy troops using them as landing stages. Around this time an estimated 30,000 people were evacuated from the borough. This was quite a reversal, as in September of the previous year Brighton itself had been flooded with evacuees from London. But after the fall of France and the realisation that the German Army was poised across the Channel, the situation was reassessed. For those that remained, a curfew was imposed between six in the evening and seven in the morning. Below we see Brighton Pier today.

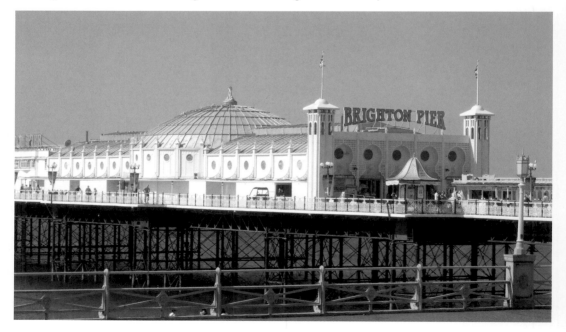

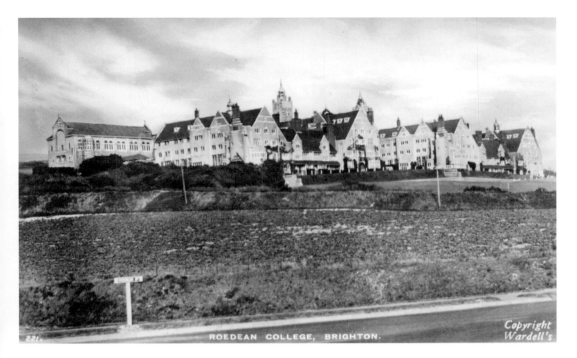

ROEDEAN COLLEGE, BRIGHTON.

Roedean College

At the start of the war, Roedean College (now school) in Brighton received girls from Francis Holland School in Clarence Gate. But in 1940, these evacuees, along with most Roedean girls, were moved up to Keswick in the Lake District as the Army commandeered the school. Later it was taken over by the Royal Navy and became HMS *Vernon*, home to over 30,000 sailors attending the Mining and Torpedo School and working for the electrical branches of the Navy. As a result of this period, Roedean is perhaps the only girls' school in the country to have an Old Boys' Association. Above and below are contemporary and modern views of the establishment.

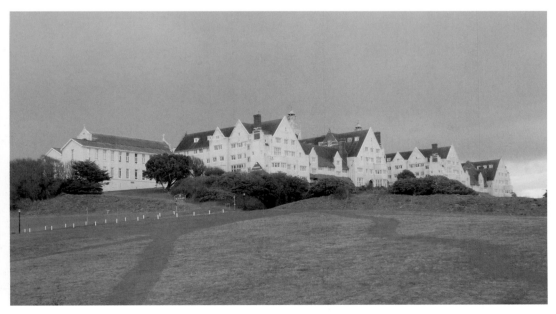

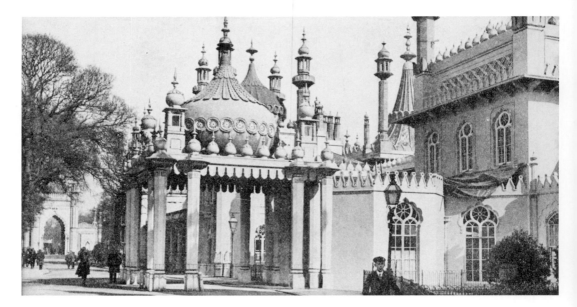

An Interim HQ

Stories have always persisted that Adolf Hitler planned to use the Royal Pavilion as an interim headquarters once his troops had secured a beachhead along the south coast. Although the source of this story was a broadcast by the Nazi propagandist William Joyce, better known as Lord Haw-Haw, there was probably no actual substance to it. But in terms of bombing, Brighton was certainly one of the most targeted locations in the county, which between July 1940 and March 1944 was subjected to fifty-six air raids which left 198 civilians dead. Above and below we see the entrance to the Royal Pavilion before the war and today.

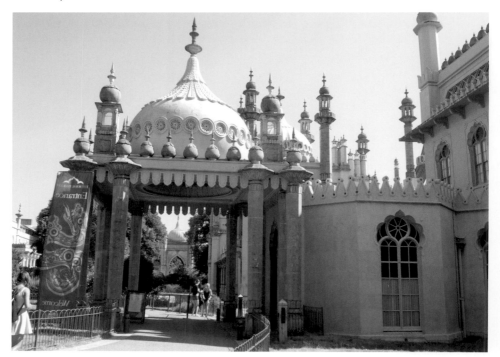

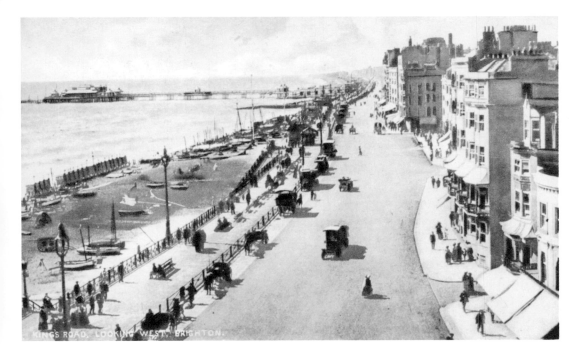

Death in the Odeon

Above we can see the King's Road in Brighton before the war and below as it looks today. The worst single raid on Brighton was on the afternoon of Saturday 14 September 1940 when the Odeon Cinema in Kemp Town was among the places bombed. Suddenly, out of a clear blue sky appeared the Luftwaffe who commenced to drop their bombs as they crossed the coastline. The cinema received a direct hit, killing four children and two adults and injuring many hundreds. Forty-nine other people were killed in the surrounding area, making a total of fifty-five. The second-worst incident was on 25 May 1943 at midday.

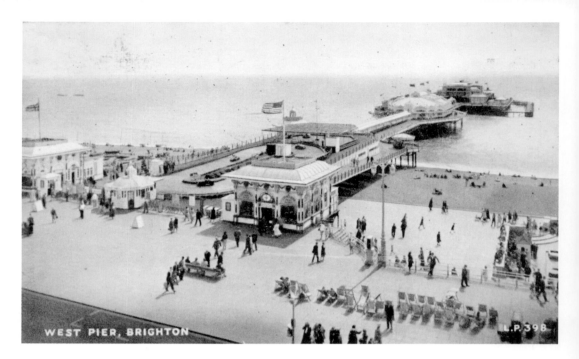

WEST PIER, BRIGHTON L.P. 398

Tip and Run on a Grand Scale

In this attack twenty-five to thirty Focke-Wulf 190s dropped twenty-two 500kg bombs and machine-gunned people in the streets indiscriminately, leaving twenty-four people dead and fifty-eight seriously injured. The dead were ten men, twelve women and two children. Some 150 houses were made uninhabitable and more than 500 people were made homeless. One of the central piers in the 20-metre-high London Road railway viaduct was demolished and there was severe damage to railway workshops and rolling stock, which were probably the target of this larger-than-average tip-and-run raid. Above we can see the West Pier in all its former glory while below we see its sad remains today.

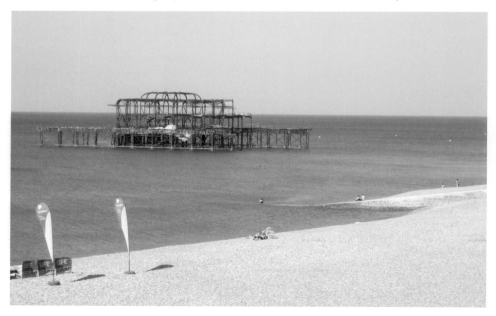

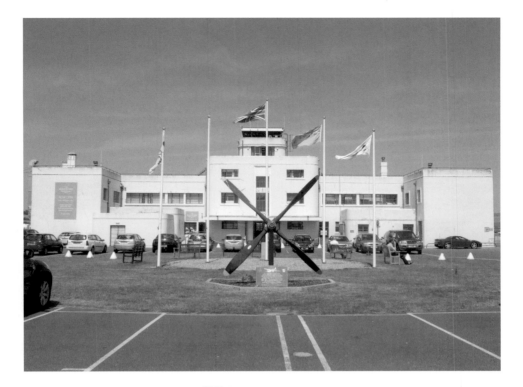

RAF Shoreham

Today, similar to most large urban centres, Brighton and Hove has its own city airport, which is on a site that in the 1940s was another important airbase, then known as RAF Shoreham, which can be found just to the west of Shoreham-by-Sea. It is renowned for its Grade II listed Art Deco terminal building. It first opened under the name of Brighton, Hove and Worthing Joint Municipal Airport. Above is the terminal building today and below is a plaque in the entrance which commemorates the ceremony in June 1936 when the airfield was opened jointly by the mayors of the three boroughs, Edward Denne (Brighton), Charles Stratton (Hove) and William Tree (Worthing).

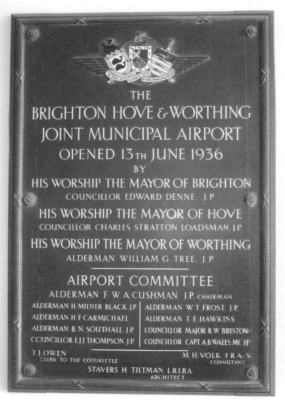

THE
BRIGHTON HOVE & WORTHING JOINT MUNICIPAL AIRPORT
OPENED 13TH JUNE 1936
BY
HIS WORSHIP THE MAYOR OF BRIGHTON
COUNCILLOR EDWARD DENNE. J.P.
HIS WORSHIP THE MAYOR OF HOVE
COUNCILLOR CHARLES STRATTON LOADSMAN. J.P.
HIS WORSHIP THE MAYOR OF WORTHING
ALDERMAN WILLIAM G. TREE. J.P.

AIRPORT COMMITTEE
ALDERMAN F. W. A. CUSHMAN. J.P. CHAIRMAN

ALDERMAN H. MILNER BLACK. J.P.	ALDERMAN W. T. FROST. J.P.
ALDERMAN H. F. CARMICHAEL	ALDERMAN T. E. HAWKINS
ALDERMAN B. N. SOUTHALL. J.P.	COUNCILLOR MAJOR R. W. BRISTOW
COUNCILLOR E. J. THOMPSON. J.P.	COUNCILLOR CAPT. A. B. WALES. M.C. J.P.

T. J. OWEN M. H. VOLK. F.R.A.S.
CLERK TO THE COMMITTEE CONSULTANT
STAVERS H. TILTMAN. L.R.I.B.A.
ARCHITECT

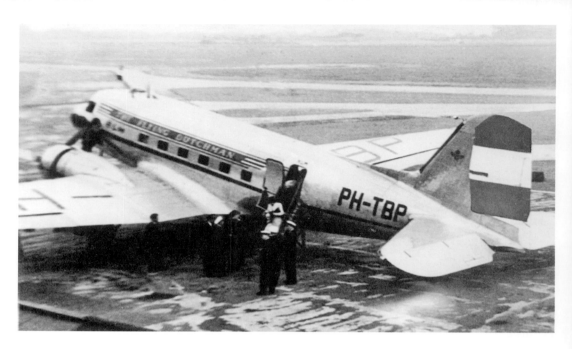

A Civilian Airport at First

In the late 1930s the airport was managed by the Croydon-based Olley Air Services, and when the war began a number of international airline operators moved their business here, including Sabena, the national airline of Belgium; DDL, the Danish operator; KLM from Holland; and Imperial Airways, the predecessor of British Airways. Above we see a Douglas DC-3 belonging to the airline operator KLM. With the German invasion of France and the Low Countries in 1940, the passenger traffic to and from Shoreham was stopped and after a short break the Royal Air Force took over its running. Below are pictured some of the original buildings at the site.

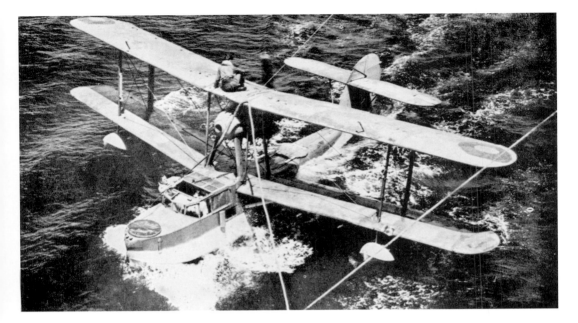

Air-Sea Rescue

Although the base was initially designated as a fighter airfield, it was decided to move part of 277 Air-Sea Rescue Squadron here, the squadron being equipped with a variety of aircraft, including the Supermarine Walrus (above). By the end of the war the squadron was involved in the rescue of nearly 600 Allied aircrew. Outside the terminal building is a memorial which incorporates the propeller of a Martin B-26 Marauder that came down in the English Channel in June 1944. It is dedicated to all British, Commonwealth and Allied servicemen and women who gave their lives during both world wars. Below is the dedication on the monument.

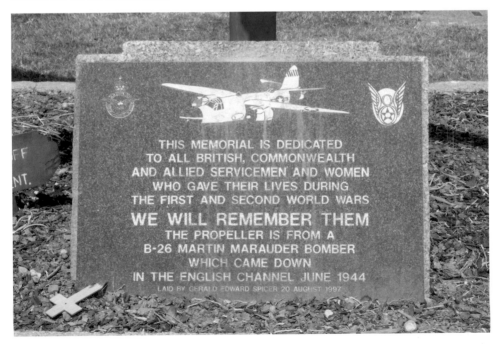

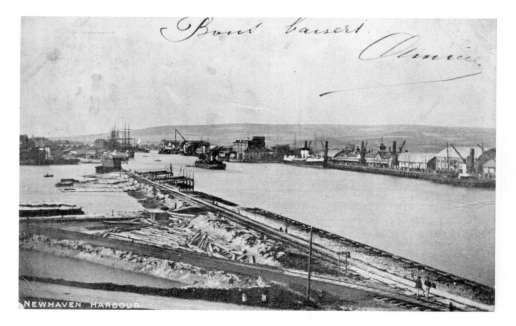

NEWHAVEN HARBOUR

Sailing to Dieppe

A little further along the coast we arrive at Newhaven, which played a particularly important role during the ill-fated raid on Dieppe in 1942. From here, fifty-nine of the landing craft that were used that day set out on the evening of 18 August. They were carrying men and equipment of the 14th Canadian Army Tank Battalion, the Camerons of Canada and No. 3 Commando. Once out of the harbour they rendezvoused with vessels from Portsmouth, Southampton and Shoreham for the crossing to France. Above is an old postcard of Newhaven Harbour, which is seen again below in its current state, now catering for pleasure craft as well as its traditional uses.

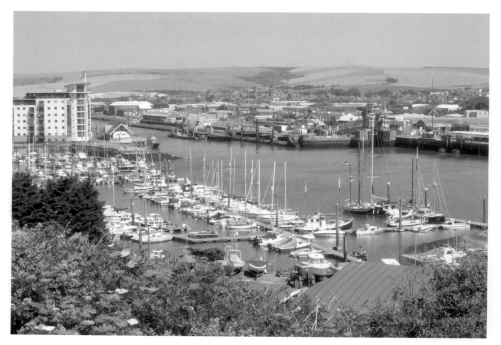

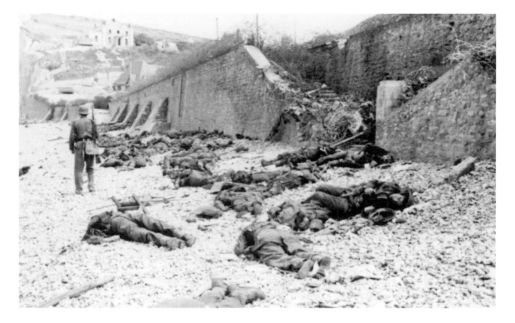

A Disastrous Commando Raid

The assault on Dieppe called for attacks at five different points on a front of roughly ten miles. But few locations along the French coast could have been less suitable for this type of attack. The high cliffs which lined the main landing beaches gave very little cover for the troops as they landed and provided the defenders with wonderful vantage points. The tanks were not equipped to cope with the conditions either, especially the vertical concrete sea-defence walls that fronted the town, which can be seen in the photograph above after the attack had failed. Below is the outer harbour at Newhaven to where some of the survivors later returned.

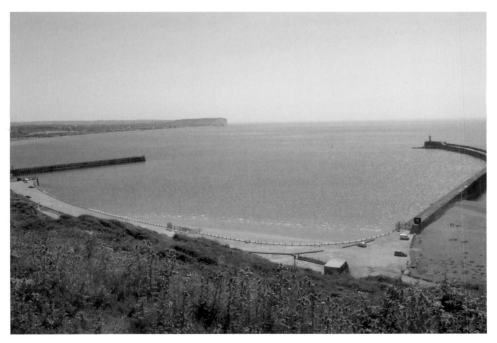

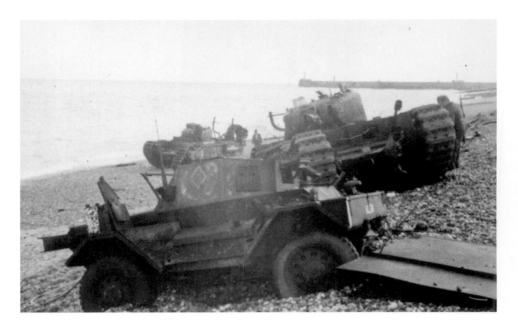

Honouring Those who Perished

The intelligence provided to the troops who were to assault Dieppe was very poor and information concerning the German defences was hopelessly out of date. In the light of all this, it seems quite incredible that the scheme was sanctioned in the first place. Above we see Allied vehicles abandoned at Dieppe after the raid. A memorial (below) dedicated to Royal Canadian Engineers who lost their lives during the raid was unveiled in 1977 in South Way, Newhaven, which is now the focus of an annual commemoration service. There is also a holm oak which perpetuates the memory of all members of the Allied naval force who died that fateful day.

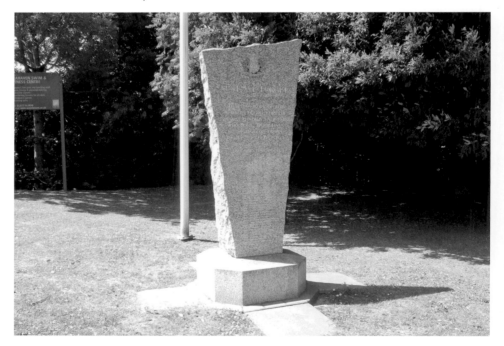

HMS *Forward*

Less well known is the fact that during the Second World War there was a secret intelligence centre known as HMS *Forward*, to the north-east of Newhaven at South Heighton. The main entrance to the complex was inside what prior to the war had been the Guinness Trust Holiday Home, remnants of which can still be seen in the aptly named Forward Close (below). From there, a long flight of steps led deep inside the earth to a network of tunnels which contained the most sophisticated communications devices then available (above). All the radar stations along the Sussex coast reported to the centre, who in turn liaised by teleprinter with similar centres at Dover and Portsmouth.

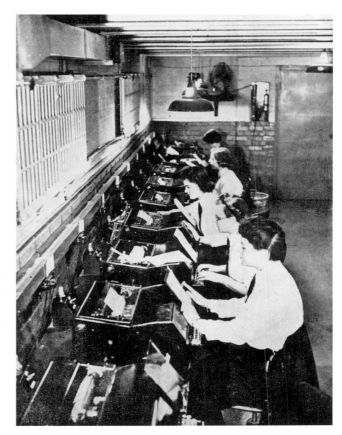

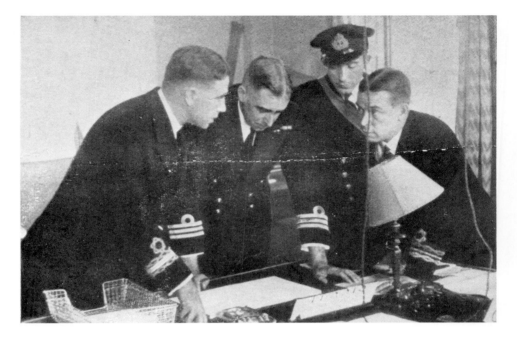

Comprehensive Cover

Together these intelligence posts provided comprehensive intelligence about everything moving on, over, or under the English Channel. Above a group of naval intelligence officers is seen perusing the data. There is very little evidence in the village today of what took place here all those years ago, but a bench on the green which was donated by a local farmer at least gives us a subtle clue, with the words 'HMS Forward 1940–1945' cut out of the metal (below). For those interested, there are several exhibits related to the site on display at the nearby Newhaven Local and Maritime Museum.

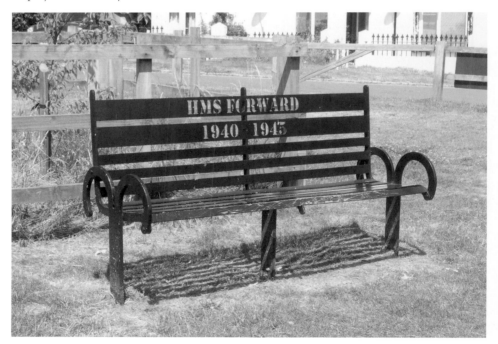

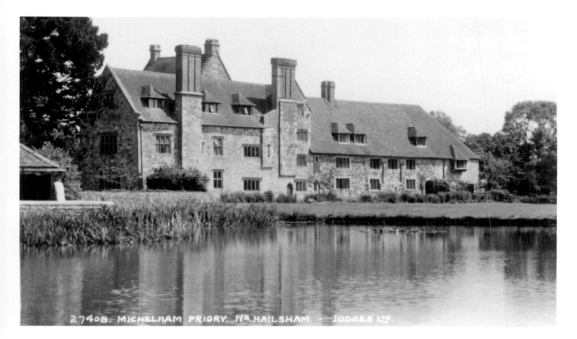

27408. MICHELHAM PRIORY. Nᴿ HAILSHAM. - JUDGES' Lᵀᴰ.

A House with Varied Uses

Before the Dieppe raid, Canadian soldiers were billeted throughout the county of Sussex, many of whom found themselves at the stately Michelham Priory near Upper Dicker. Here they drew a plan of the raid on the wall of the gatehouse, which apparently remains to this day. Michelham, similar to many large country houses, had a rich wartime history. Evacuees from Rotherhithe were accommodated here for a few months at the start of the war. The owners, Mr and Mrs Beresford-Wright, left for the duration, although one of their daughters, who was a member of the Women's Land Army, remained to work and maintain the land. Later it was also used by the Auxiliary Territorial Service.

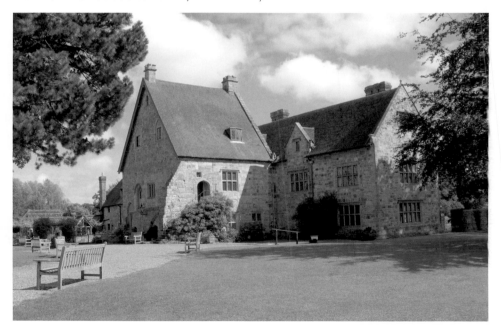

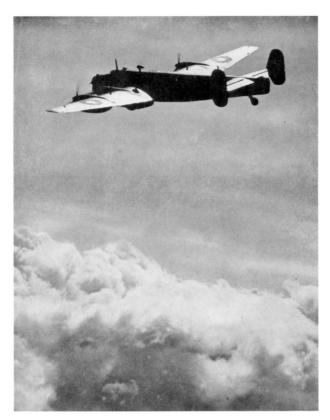

Bomber Command Memorial

Our next stop is Beachy Head, the highest chalk cliff along the south coast, which rises just to the west of Eastbourne. It was the site of one of Britain's wartime radar stations and today is the location of the Bomber Command Memorial (below), which was unveiled in July 2012 after being airlifted there by an RAF Chinook helicopter. The reason why this site was chosen was that from 1942 onwards Beachy Head was the point from which all RAF bombing raids to targets in the central, southern and eastern parts of enemy-held territory left the mainland. Above is a study of a British bomber taking part in a wartime mission.

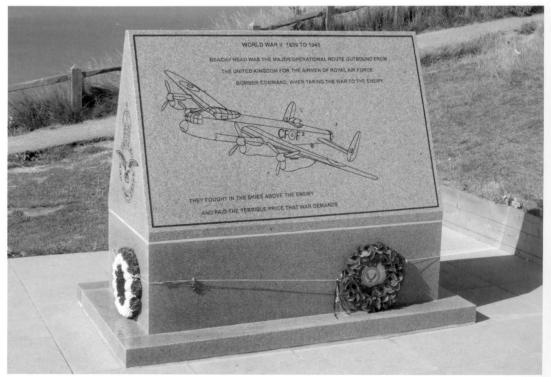

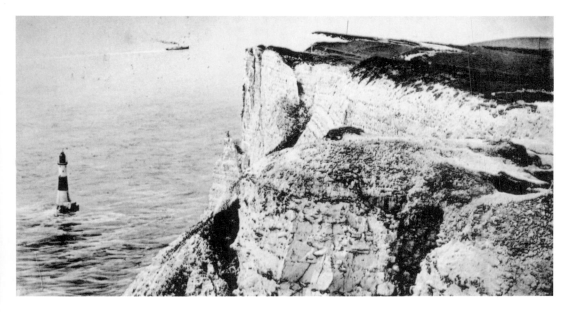

First Loss in the Channel Bombings

Around 110,000 men took part in these missions and the monument is dedicated to the 55,573 who didn't return. The white cliffs of Beachy Head (above and below) would have been their very last sight of England. This stretch of the coast was also the setting for one of the first incidents of the war. It took place off Eastbourne on 20 March 1940 as the merchantman the SS *Barn Hill* was sailing through the English Channel and was attacked by a lone raider shortly after 10.30 p.m. Four crewmen were killed and the remainder were rescued by the Eastbourne Lifeboat. Shortly afterwards the ship was beached at Langney Point. She was the first craft to be lost in the Channel bombings.

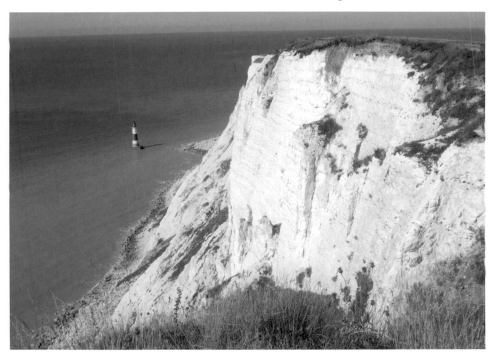

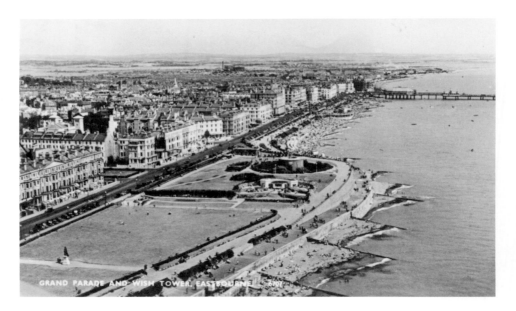

GRAND PARADE AND WISH TOWER, EASTBOURNE

Using the Facilities Left by the RAF

The local police adopted the now demolished guardhouse at the entrance to Beachy Head radar station after the RAF moved out, as it made an ideal site to kennel their dogs and stable the horse used by the Downs Ranger, who, during and after the war, was Police Constable Harry Ward. From this location he was in a better position to attend the cliff rescues that were part of his duties. Harry was lowered many times over the cliff edge on primitive rescue equipment to recover suicide victims and dogs that had fallen and become lodged on the ledges below. Today there is a plaque (below) dedicated to Harry and his horse Jumbo on Beachy Head. Above we have an earlier view of Eastbourne taken from the cliff tops.

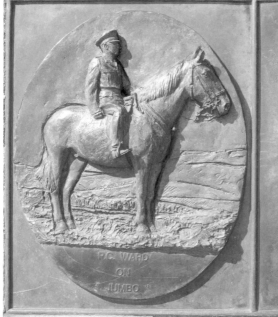

IN MEMORY
OF
P.C. HARRY WARD
B.E.M. E.R.D.
1912 - 1974

The Downs Ranger
who patrolled Beachy Head
on his horse for many years,
before retiring in 1966.
On numerous occasions
he risked his life attempting
to save others.

P.C. WARD
ON
JUMBO

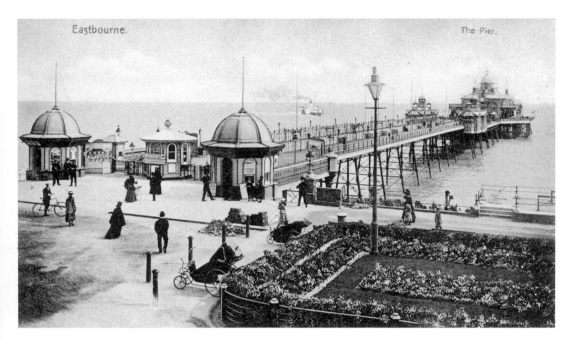

Eastbourne. The Pier.

Eastbourne Expects

The people of Eastbourne soon became used to the sight of daylight attacks by the Luftwaffe on the convoys of ships as they passed the shoreline, while at night they could hear the enemy dropping mines in to the water. Eastbourne itself was affected by the war in a number of ways. Initially, children were evacuated here on the assumption that they would be safe, but after the capitulation of France it was feared that the town would be within the invasion zone. At this time, similar to Brighton and other south coast towns, a section of the pier was removed to prevent the enemy using it to land troops. Above is an old postcard of the pier, pictured below as it looks today.

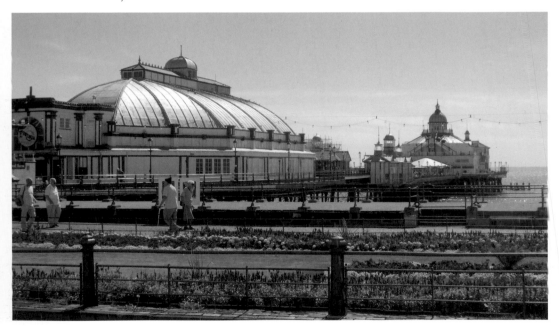

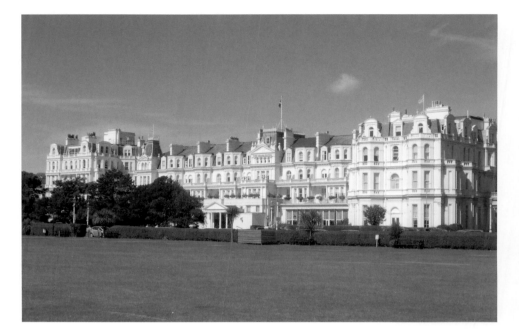

Hotels Requisitioned for the War Effort

Many people decided to shut up their homes and move away from the coast, while restrictions on visitors coming to the resort forced a number of hotels to close, most of which were later requisitioned by the armed forces. Some of these establishments, such as the Grand, pictured above today, were used to accommodate potential aircrew from many Allied nations, such as Poland, Czechoslovakia and France. At the Winter Gardens, seen below, they were taught to speak English before going on to further training and to eventually join their squadrons wherever they were needed.

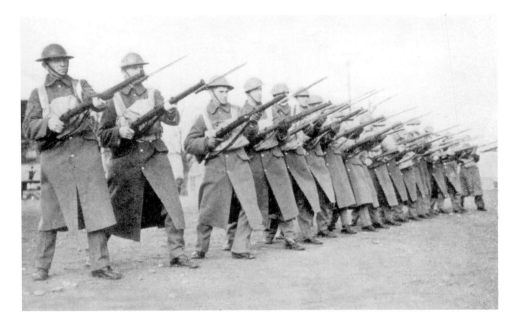

The Royal Sussex Regiment

From July 1941 until D-Day, thousands of Canadian soldiers were billeted in and around the town, such as those seen training above. Many were accommodated at the Redoubt Fortress on Royal Parade, which had originally been built in the early nineteenth century to stop a threatened invasion by the French. Below we see some of the accommodation at the fort today. Similar to most British counties, Sussex had its own military bodies and the museum of the Royal Sussex Regiment is actually housed within the Redoubt Fortress, where you can get some idea of the various campaigns in which local men served during the Second World War.

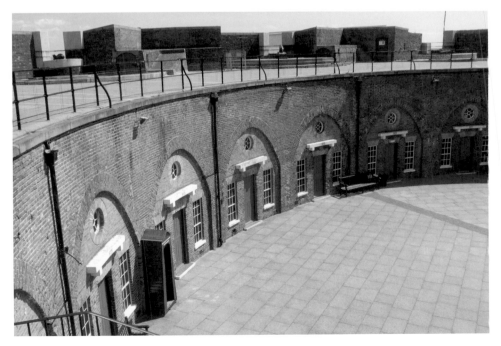

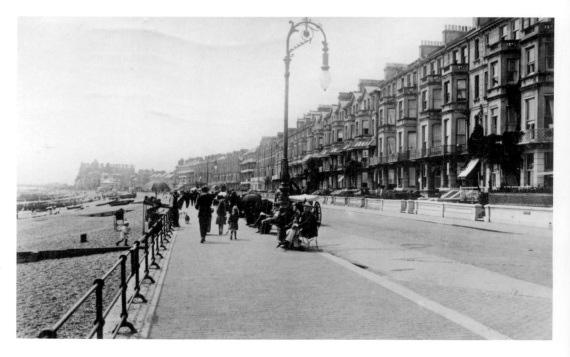

Raids on Eastbourne

Eastbourne suffered badly from bombing and by the end of the conflict it was designated by the Home Office to have been 'the most raided town in the south-east region outside of London'. The ARP issued 1,350 red warnings, of which 112 were recorded as involving enemy activity. This left over 10,000 properties damaged, with 475 completely destroyed. Some 172 civilians were killed in the borough, as well as twenty-eight service personnel. The postcard above depicts the Royal Parade before the war, which is seen again below as it appears now.

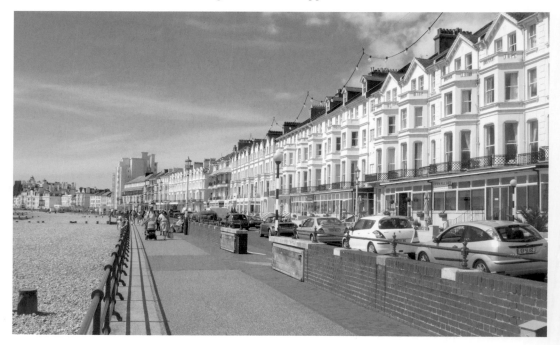

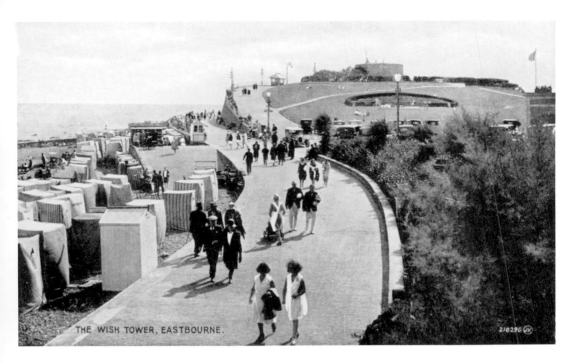

THE WISH TOWER, EASTBOURNE.

A Devastating Attack

One of the worst raids on the town took place on 8 December 1942 at around 2 p.m. Being close to Christmas, the streets were crowded with shoppers. The air-raid sirens sent people running for shelter as a Dornier 217 came low across the town, dropping four high explosive bombs. Several shops came crashing down, burying many people under tons of rubble. Eighteen were killed and thirty-seven injured. Above, we can see the seafront at Eastbourne as it appeared in the 1940s, with the Wish Tower on the hill. The Wish Tower, seen below today, was a Martello Tower built in the early nineteenth century to guard the coast from Napoleon Bonaparte's troops.

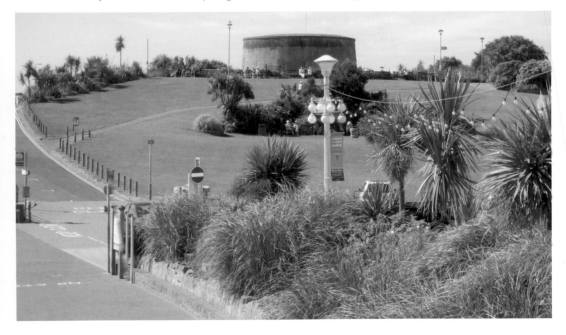

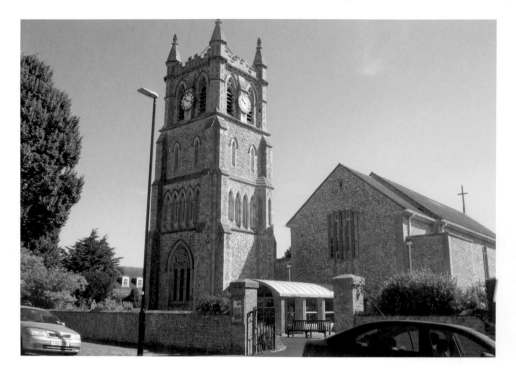

A Quirky Reminder of Eastbourne's Suffering

On 7 March 1943, just before 1 p.m., a mixed group of sixteen Messerschmitt 109s and Focke-Wulf 190s approached the coast at less than twenty feet. At the last minute they cleared Beachy Head to swoop down on the town. On this occasion fourteen were killed and fifty-nine injured. And so the catalogue goes on. The area of Eastbourne known as the Meads was hit several times. Here St John the Evangelist church (above and below) was severely damaged on 4 May 1942. The tower, which is now free-standing, was duly repaired. The rest of the church was rebuilt in the 1960s in contemporary style and now provides us with a quirky reminder of Eastbourne's wartime suffering.

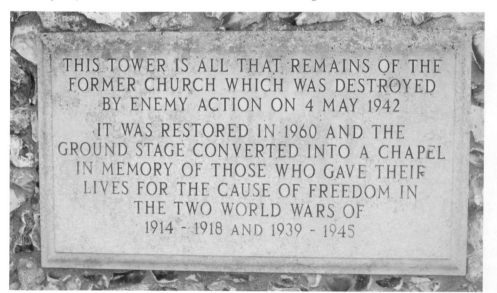

THIS TOWER IS ALL THAT REMAINS OF THE FORMER CHURCH WHICH WAS DESTROYED BY ENEMY ACTION ON 4 MAY 1942

IT WAS RESTORED IN 1960 AND THE GROUND STAGE CONVERTED INTO A CHAPEL IN MEMORY OF THOSE WHO GAVE THEIR LIVES FOR THE CAUSE OF FREEDOM IN THE TWO WORLD WARS OF 1914 - 1918 AND 1939 - 1945

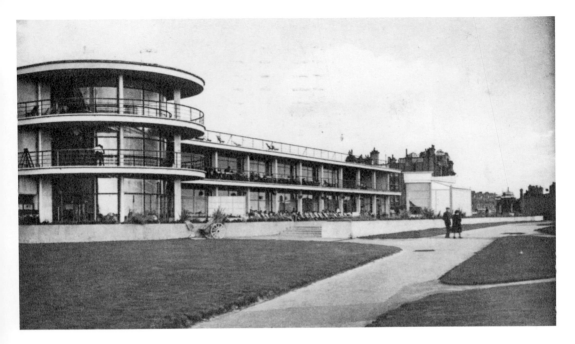

No Laughing Matter

Bexhill-on-Sea was subjected to fifty-one air raids, during which twenty-two people died. Above is an old postcard of one of its most famous buildings, the De La Warr Pavilion, which opened in 1935. During the war it was used constantly by the military, and among those who are known to have served there, was the comedian Spike Milligan, who served in the Royal Artillery. The building suffered minor damage to its foundations when the Metropole Hotel, adjacent to the building's western side, was destroyed by German bombs. Below is a vintage postcard showing something of the inside of the pavilion.

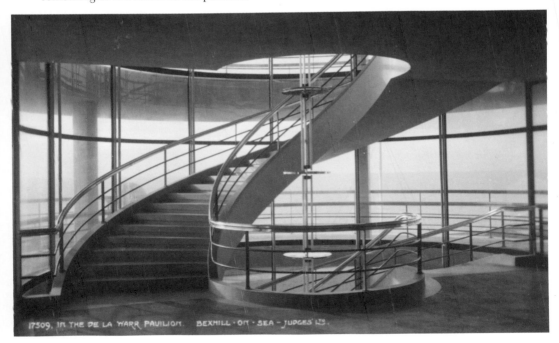

17509, IN THE DE LA WARR PAVILION. BEXHILL · ON · SEA — JUDGES' L⁹.

Evacuation of Sussex Sheep

It is sometimes claimed that part of Operation *Sealion* was to establish a beachhead between Rye and New Romney. Winchelsea Beach became part of the Rye Defence Area and a prohibited zone for civilians. Pett Level was flooded and families who had been evacuated there from London were sent elsewhere, along with 85,000 sheep, which were taken by train to Yorkshire. Winchelsea itself was garrisoned and two Bofors guns were emplaced either side of the Strand Gate. The old Court House Hall, seen at the right of the above postcard from the 1930s and below today, was used to accommodate troops.

Worst Attack of the War

Of course, inland areas were also targeted by the bombers, with the worst single incident of the war occurring on Friday 9 July 1943 in East Grinstead. It was late afternoon when the pilot of a Dornier 217 was thought to have targeted a group of Army trucks parked near the High Street. In the resulting attack 108 people died, many of whom were in the Whitehall Cinema watching a film featuring Hopalong Cassidy, and another 235 were injured. Apparently, before the bomb struck a warning appeared on the screen in the cinema that an air raid was in progress, but few of the audience, mostly children, took any notice. Above we see the cinema after the attack and below in its current state.

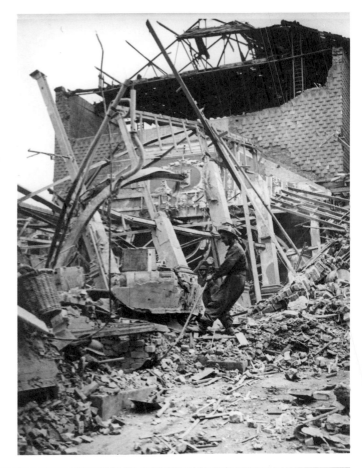

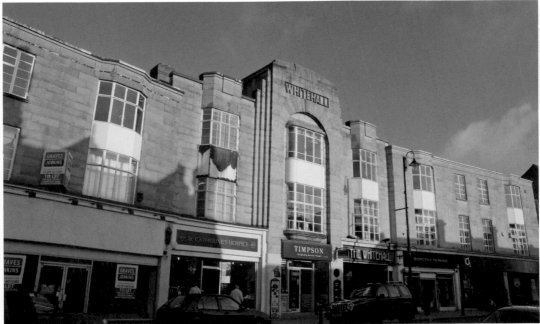

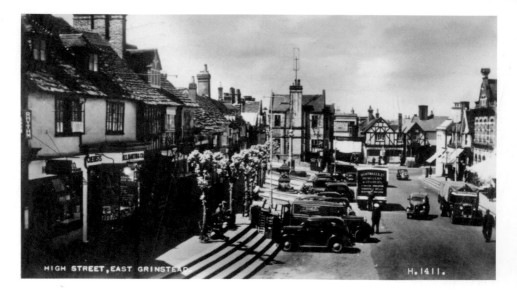

HIGH STREET, EAST GRINSTEAD. H.1411.

In Peace and War

The photograph above of East Grinstead High Street was taken in 1939 just prior to hostilities. During the war the town's Queen Victoria Hospital was used as a specialist burns unit by Sir Archibald McIndoe and became famous for its pioneering treatment of RAF and Allied aircrew who were badly burned or crushed and required reconstructive plastic surgery. Most famously it was where the Guinea Pig Club was formed in 1941, which then became a support network for the aircrew and their family members. The club still provides assistance for Guinea Pigs, and meets regularly in East Grinstead. Below is another view of the High Street following an air raid on the town.

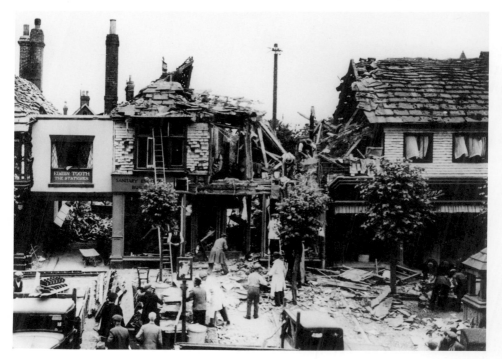

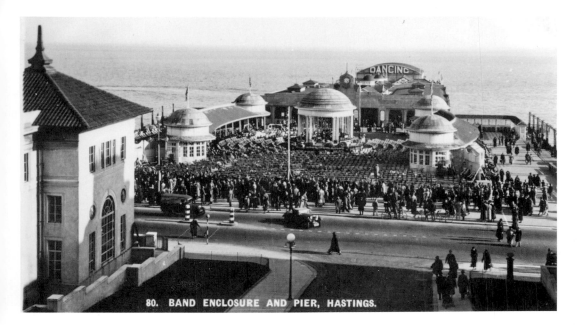

80. BAND ENCLOSURE AND PIER, HASTINGS.

Final Destination

The final destination of our tour along the Sussex wartime coast is a town very much associated with the last successful invasion of England – Hastings – although in point of fact, the Norman army of William the Conqueror actually came ashore at Pevensey in 1066. Hastings experienced eighty-five visits from the Luftwaffe, during which they dropped 550 high explosive bombs, while sixteen flying bombs also hit the town. Around 15,000 properties were damaged, with 463 destroyed. Above we can see the pier in its heyday. Below is the pier photographed in 2010, although in October of that year it was burnt down by arsonists.

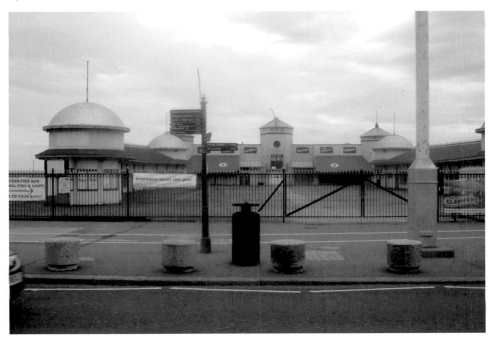

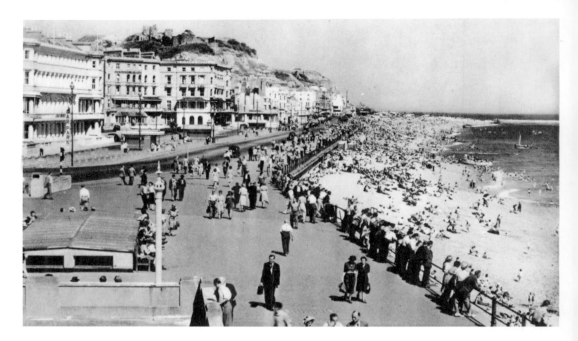

Best Air-Raid Shelter in Britain

In the bombing of Hastings, 154 lives were lost. The town had no anti-aircraft guns until mid-October 1940, so throughout the Battle of Britain it was left at the mercy of enemy pilots. At the height of the invasion threat, the population of Hastings almost halved to 34,000 as people voluntarily evacuated the town. For those who decided to remain, St Clements Caves (below) were used as a natural air-raid shelter which provided protection for around 600 people. An inspector from the Civil Defence Commissioner remarked that it was 'the best air-raid shelter in the country' despite being in the worst corner for enemy attacks. The above postcard shows the busy Esplanade in the 1930s.

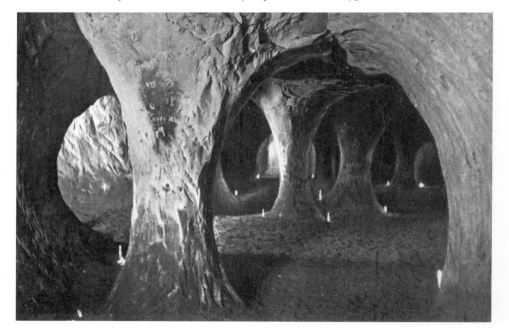